POSTCARD HISTORY SERIES

Canton

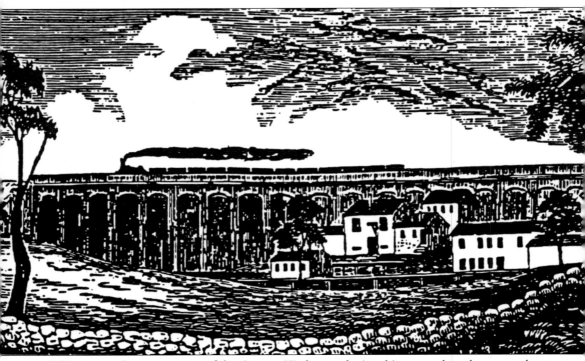

This is a southwestern view of the Canton Viaduct as depicted in a woodcut drawn on the spot and published in *Massachusetts Historical Collections* by John Warner Barber in 1839. The author created this postcard in 1990. (Author's collection.)

On the front cover: Pictured here is the viaduct in Canton around 1933. (Courtesy of the Canton Public Library, Daniel Keleher Collection.)

On the back cover: Here is a familiar look at a Canton Center streetscape, taken from the intersection of Washington and Bolivar Streets in the mid–1950s. Angled parking was a wonderful way to allow for increased space and access to the shopping center at a time before malls and online shopping. (Author's collection.)

Canton

David
Is am hoping
that you'll enjoy this
Book
love +
Merry Christmas
2011
Luke luliama

George T. Comeau

ARCADIA
PUBLISHING

Published by Arcadia Publishing
Charleston SC, Chicago IL, Portsmouth NH, San Francisco CA

Printed in the United States of America

Library of Congress Control Number: 2009926602

For all general information contact Arcadia Publishing at:
Telephone 843-853-2070
Fax 843-853-0044
E-mail sales@arcadiapublishing.com
For customer service and orders:
Toll-Free 1-888-313-2665

Visit us on the Internet at www.arcadiapublishing.com

*Dedicated to the local historians who helped shape my understanding of
Canton and the richness of our history. Closest to my heart, my wife
Patricia, thank you for your love, tolerance, guidance, and support.*

CONTENTS

ACKNOWLEDGMENTS

Growing through the years, so many local historians helped me understand this town, and although they are no longer with us, they live on in our memory: Edward Bolster, Dan Keleher, Edward Lynch, Edmund Kenealy, and Eugene Williams. No less important are the historians that I turned to throughout this project: James Roache, Wally Gibbs, Peter Sarra, Ed Costanza, Chris Brindley, Patricia Johnson, Jim Fitzpatrick, David Lambert, and Arthur Krim. Special thanks to my editor at Arcadia Publishing, Erin Rocha.

The facts and additional historical details came from sources that have been preserved at the Canton Historical Society (the "Histy") and the Edward Bolster Local History Room at the Canton Public Library.

Local history is largely made up from what has been preserved as artifacts and stories handed down over the centuries. In this case, the postcards and photographs in this book came from five major sources. Aside from my personal collection, many of the images came from a collection of cards that were given to the Canton Public Library through the estate of Daniel C. Keleher. It is perhaps the genesis of this book that evolved from seeing Dan's collection so many times throughout my life. Two other major sources for images in this book came from the private collections of Charles S. Crespi and Peter Sarra. Charlie and Peter have been collecting postcard images of Canton for many years, and taken as a whole, these two collections represent close to all of the postcards ever taken of Canton subjects.

Other sources include the Canton Public Library, the Canton Historical Society, the Canton Citizen, the Canton Courier, and the Canton Historical Commission. Every effort has been made to supply complete and accurate information. History has a way of shifting with time, and advice about errors or general comments are greatly appreciated.

Finally the Canton Historical Society, headed by Wally Gibbs, provided all the wonderfully rare images that support the interpretations of the postcards in this book.

Unless otherwise noted, all images are from the author's collection.

INTRODUCTION

It began one day when I learned that I was failing U.S. History. It was basic history, a high school requirement, and I was just not connecting with the subject matter. The teacher decided that I would be given one last chance to pass the course. The final assignment was to "write a paper on a subject of history that is of interest to you." As a child growing up in Canton, there is one solidly historic topic that just about everyone is aware of, the Canton Viaduct. This is an impressive stone arch bridge that was built in 1834, and it was located less than half a mile from my home on Walpole Street. This would become my passing grade. I went to the library and dug through the pamphlet files and the microfilm. A visit to the Canton Historical Society yielded more information. Local folklore and stories told by town elders filled out the story. The paper was written, submitted, and graded, yielding a passing grade for the course and an A on the thesis. Amazingly it was local history that paved the way for me to go to college and become a successful person.

This same fascination with the viaduct gave way to collecting images of Canton that had travelled far beyond the town and the close vicinities. Whenever I found myself in an antique shop or a used bookstore, invariably I would cull through the postcard bins seeking cards of the viaduct, the Blue Hill Observatory or other historical sites related to Canton. A modest collection blossomed with the advent of eBay and consultation with other local collectors. One particular local collector was a great source for cards that showcased Canton: Dan Keleher. Dan had the finest set of postcards that I had ever seen, and it was always amazing to me that he built his collection up before the Internet had even begun to make finding these cards with ease possible. Postcards were easily transported to local meetings and discussions, and they would be passed around the room so we all could share the views and stories of our town at the beginning of the 20th century.

When the time came to create a book devoted almost exclusively to Canton postcards, it was apparent that a small personal collection of images would not suffice. How many postcard images of our town could possibly exist? After all, Canton is a community that had few local landmarks that would be worthy of a wide range of imagery suitable to fuel the postcard trade. Over time, the discovery process yielded more than 300 separate images that varied widely. What was a surprise was the fact that collectors like Keleher, Sarra, and Crespi were ardent competitors for the elusive and rare images that were rumored to exist.

So what is the fascination with postcards? Why do we send them, collect them, and even make them? I think the answer comes from the fact that we are proud of our community, and by the 20th century, it was an inexpensive and novel way to share a little piece of our town with a

wider world. The postcard as we know it today dates to approximately 1898. The golden age of the postcard is widely accepted as being from 1898 to 1913, and it is along these lines that many of the images from Canton are taken. The bulk of the cards are black-and-white photographic images. Many were hand-colored, and few had detailed messages on the back, as government restrictions meant to protect the postage system meant that there was precious little space on the obverse for anything other than an address.

But by 1907, messages began to appear on the back of the cards as space and government regulations allowed for short notes. There are fascinating stories that ride along on the back of the cards. More than simply "wish you were here," the backs of the cards show glimpses of love, heartbreak, pride, snippets of vacation bliss, and humor of the moment. The card on page 81 demonstrates this wonderfully as a loved one writes home two days after the 1938 hurricane, "Don't know when I will be home, some roads are impassable." The truth is, these cards satisfy a voyeuristic sense that we are reading someone else's mail, and it is open to the world on the back of these cards.

Like all early American postcards, the oldest postcards were printed in Germany, and in some cases, license was taken after the fact by adding cars, boats, and pedestrians to the cards long after the photographs were taken. As time and technology progressed, the old grainy images gave way to high contrast black and white real-photo postcards that are superbly detailed. There is a postcard in this book (page 58) where a small boy's head appears in the window of the high school. In another card, a young girl peeks from the sidewalk as the image is snapped. This is the fun of discovery that happens when studying these cards. The excitement is in the stories that each card tells. When it was printed, where it was posted, the messages contained on it, and the distance it travelled, all come back to Canton.

This is an evolving collection of views that tell people what we valued and found worthy to photograph at a time when Canton was a sleepy suburb of Boston with a bucolic history being challenged by new industry and evolving transportation systems.

As you look at these images, know that each one tells a story of the many facets that have shaped our community. The images of the viaduct speak to our community's early strength as an industrial town that used one of the first railroads in America as a distribution point for products that would enrich the workforce and the lives of our citizens. The viaduct is perhaps the most photographed landmark in Canton, and as there is only one other structure of its kind in the world, it holds a national and international place of interest in civil engineering history due to its longevity and unique design.

The photographs of Washington Street are a steady progression from the waning days of the horse and carriage and into the automobile era. With the most recent revitalization of the downtown business district, the tree-lined street has begun to reappear, the pedestrian friendly walks are again in use, and the streetscape architecture of another time creates a connection to some of the images in this book.

By the time many of the images in this book were taken, the community had begun a period of significant growth. The young immigrant families that came here were a significant source of labor for the mills and shops that served Canton. Postcards were sold to mill workers who would send quick notes home to show their families what life was like in modern Canton.

Perhaps the reader will discover new ways to look through the lens of another time. Many of the subjects in this book are still with us today, and this will provide a visual primer for historical reference at the dawn of the 20th century. Like the joy of the original sender, this collection of postcards from Canton is a joy to share with a modern audience and perhaps will yield an increased interest in the history of our places and people.

One

At the Foot of the Great Blue Hill

The most prominent geographic landmark in Canton is perhaps the Great Blue Hill. The earliest settlements that extended from Dorchester were in this section of the northernmost boundaries. Many woodland paths still exist through the Blue Hill Reservation. This postcard from 1912 welcomes visitors to Canton. (Courtesy of the Canton Public Library, Daniel Keleher Collection.)

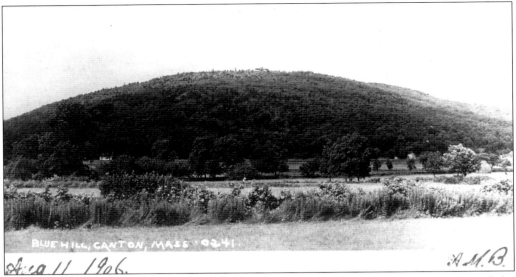

Great Blue Hill was the name that was given by early European explorers who noticed the blue tint of the geography in the distance. This photocard was published by E. Everett Rhodes, Norwood, Publishers and is postmarked 1906. (Courtesy of the Canton Public Library, Daniel Keleher Collection.)

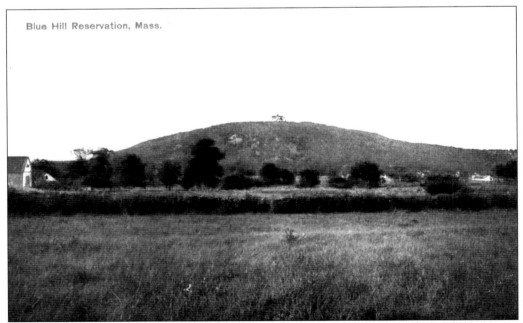

Long before Route 128 intersected the area, the base of the Great Blue Hill was dotted with farms and pastures that supported local families. By 1954, the highway project forced the removal and in some cases the relocation of dozens of ancient homes and barns. This card was made in Germany by Reichner Brothers and is dated between 1906 and 1914.

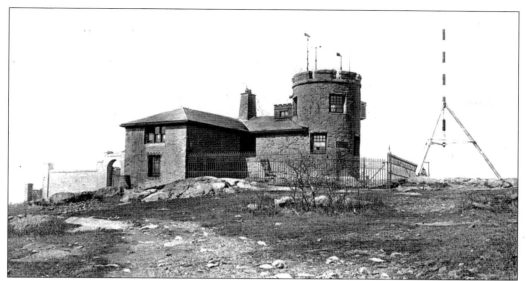

Atop the summit of the Great Blue Hill at 635 feet is the Blue Hill Meteorological Observatory. Founded in 1885 by Abbott Lawrence Rotch as a private scientific center for the study and measurement of the atmosphere, it was the site of many pioneering weather experiments and discoveries. The earliest kite soundings of the atmosphere in North America in the 1890s and the development of the radiosonde in the 1930s occurred here. The observatory is a national historic landmark. These cards show the evolution of the structure. Above is a view from 1907 showing the west wing that housed the "new" library upstairs and storage for kites downstairs and bedrooms. The card below, dated 1916, shows the 1908 renovation in which the two-story stone tower was torn down and replaced by the present three-story concrete tower.

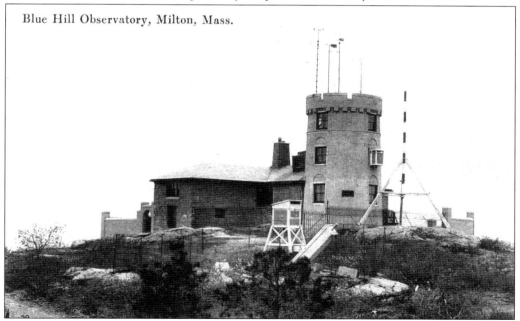

Blue Hill Observatory, Milton, Mass.

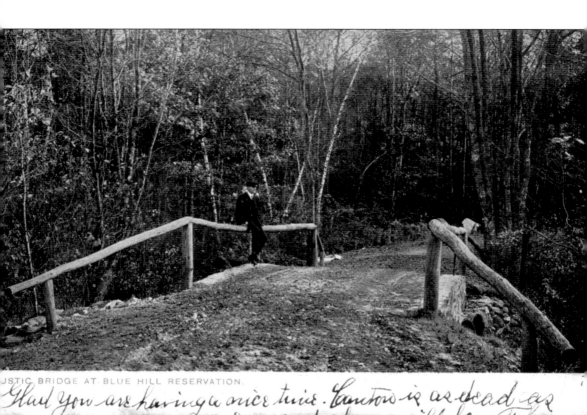

Glad you are having a nice time. Canton is as dead as ever and always will be. Flora

Laid out in 1892 by Charles Eliot, the Metropolitan Parks Commission purchased the lands of Blue Hills Reservation in 1893 as one of the first metropolitan parks set aside for public recreation in the United States. More than 7,000 acres make up the reservation, which is comprised of 22 hills. A great variety of plant and animal life thrive in the diverse habitats, including several rare and endangered species in Massachusetts, including the timber rattlesnake. In Colonial days, there was an abundance of rattlesnakes in the Blue Hill area, and Dr. Abel Puffer of Stoughton published a cure in 1770 that he had found successful on two patients, a horse and a dog. This view from 1908 shows a rustic bridge across one of the many streams that flow through the Blue Hill Reservation. The sender opines that "Canton is as dead as ever." (Courtesy of the Canton Public Library, Daniel Keleher Collection.)

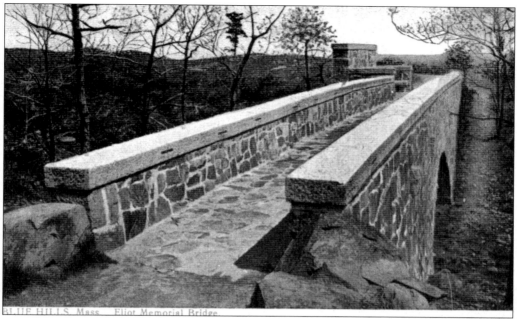

Near the summit of the Blue Hill is the Eliot Memorial Bridge, which was built in 1906. Eliot was a leading American landscape architect, whose career was cut short by untimely death at age 37 from spinal meningitis. Eliot pioneered many of the fundamental principles of regional planning and laid the conceptual and political groundwork for land and historical conservancies across the world. Working with others, Eliot created the remarkably fine esplanades of the Charles River between Cambridge and Boston. On a beautiful autumn day in 1906 at the brow of the Blue Hill, the path and bridge was dedicated to the memory of Eliot. For people who climb the summit today, the bridge is a reminder of dedication of one of America's earliest landscape preservationists.

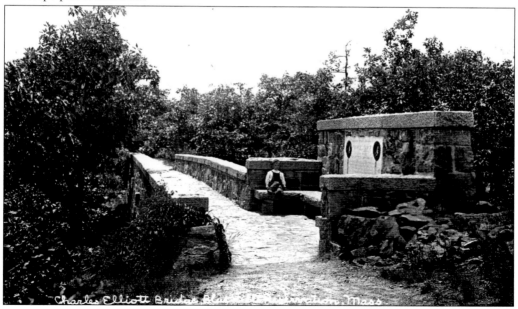

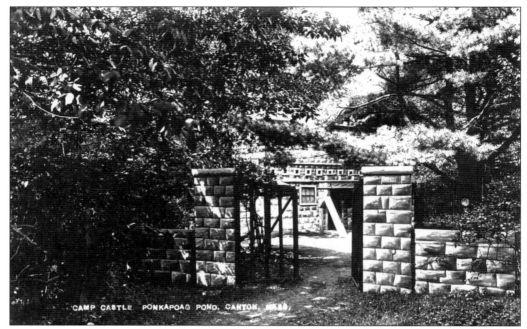

Canton served as a summer destination spot for people seeking escape from the city. Only a short trolley ride from Boston would bring one to Ponkapoag Pond and Camp Castle. This postcard shows the entrance to Camp Castle and was published by C. O. Tucker of Boston in 1913. (Courtesy of Peter Sarra.)

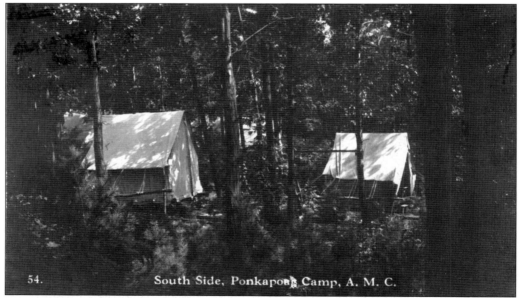

In July 1921, the Appalachian Mountain Club (AMC) established a camp at Ponkapoag Pond. Today a modern AMC camp is situated in the same oak grove on a bluff about 70 feet above the water. The camp was opened to give hikers greater access to the superb "tramping country" in the vicinity of Boston. In 1921, over 1,100 people stayed at the camp in the first four months of operation. This 1931 view shows the south side of the camp. (Courtesy of Peter Sarra.)

14

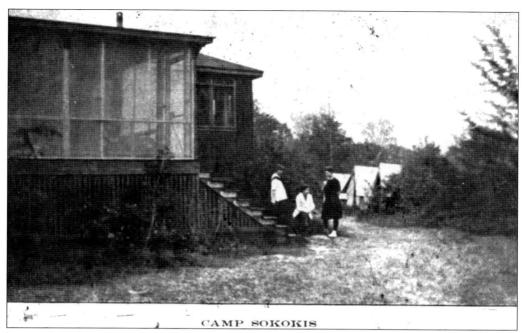

CAMP SOKOKIS

Postcards had just enough space for campers to write home and share a brief glimpse of life at camp. This message reads: "Hello, old stocking! How art thou? I don't need to tell you what a great time I'm having I suppose. I wish this was my first week here so I could look forward to another. Bye-bye. Helen." It is dated August 12, 1919. (Courtesy of Peter Sarra.)

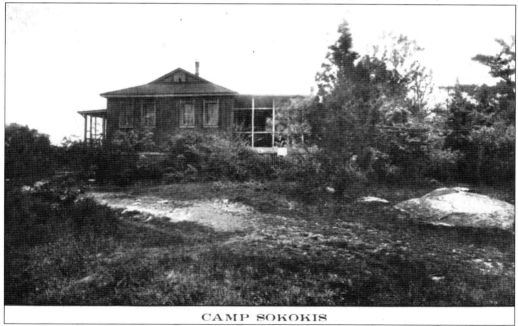

CAMP SOKOKIS

Another short note home from camp seen here reads, "Here on camp, sleep in tents, have great fun, love the life, will write again soon, Love Ellen." It is from July 5, 1921. This was a note that was certainly to the point. (Courtesy of Peter Sarra.)

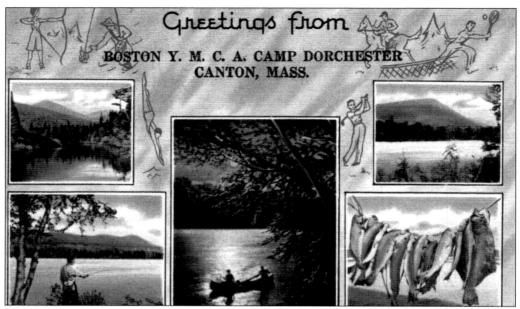

Greetings from
BOSTON Y. M. C. A. CAMP DORCHESTER
CANTON, MASS.

Founded in 1923, YMCA Camp Dorchester is located along Ponkapoag Pond. Set on 35 acres, the camp has provided thousands of young people the opportunity to spend time in the Blue Hill Reservation. Now known as the Ponkapoag Outdoor Center, the mission of improving the health of mind, body, and spirit continues. This card from 1950 was written to "Ma & Dad," and young Richie complained that he did not get much mail. (Courtesy of Peter Sarra.)

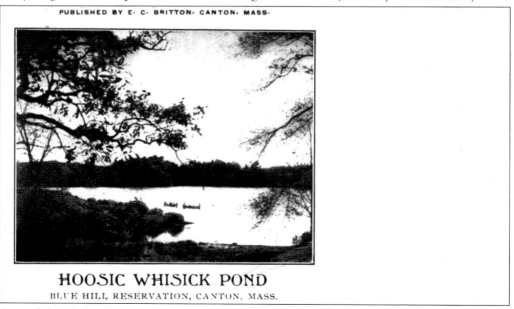

PUBLISHED BY E. C. BRITTON. CANTON. MASS.

HOOSIC WHISICK POND
BLUE HILL RESERVATION, CANTON, MASS.

One of the oldest golf clubs in America, the Hoosic Whisick Golf Club of Ponkapaog was founded in 1892. The club was forced to relocate from Houghton's Pond to its present location on Greenlodge Street when the club's land became part of the Blue Hill Reservation in 1894. The club was elected to the U.S. Golf Association in 1897. (Courtesy of the Canton Public Library, Daniel Keleher Collection.)

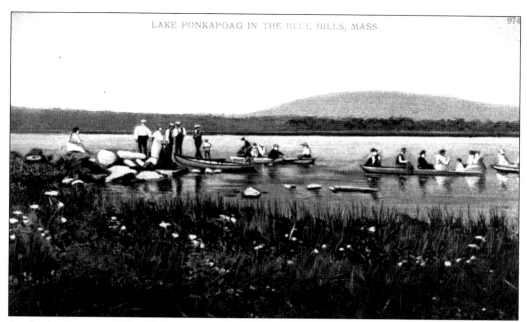

At the beginning of the 19th century there were many recreation areas and weekend camps located in and around Ponkapoag. In 1869, Henry L. Pierce purchased land abutting the pond and constructed Maple Avenue, the road that leads to the pond. Guests in the area hotels would take boat excursions out onto the pond, and it was a frequent vacation spot for families. (Courtesy of the Canton Public Library, Daniel Keleher Collection.)

Even beyond the Blue Hill Reservation, there were plenty of diversions in Canton. The Field and Forest Club of Boston was founded in 1904 and had access to a small bungalow in Canton. It was built by volunteers and managed by the club. Here the Choral Social Club outing in July 1918 at Lake Pequit can be seen. (Courtesy of Peter Sarra.)

The Kanton Kamera Klub was a local club that focused (pun intended) on photography both in Canton and around the country. Here a row onto Ponkapoag Pond in 1897 is likely to yield a superb shot of the Great Blue Hill. (Courtesy of the Canton Historical Society.)

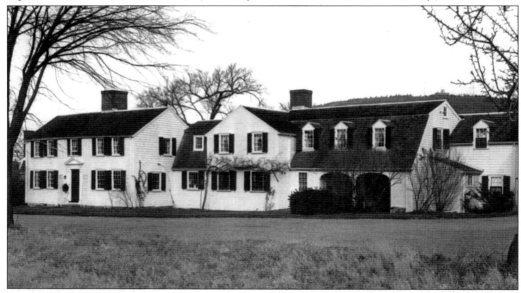

The Jonathan Puffer House is the oldest surviving house in Canton. Built in 1711, Puffer built this house with the assistance of the Ponkapoag Indians who supplied the cedar from the bogs in Ponkapoag. In 1717, John Davenport purchased the house, and it remained in the same family for 200 years. The house is located just off Farrington Lane and has an impressive view of the Blue Hill. A preservation restriction runs on the land prohibiting most uses that would threaten this historical tract of land. (Courtesy of the Canton Historical Society.)

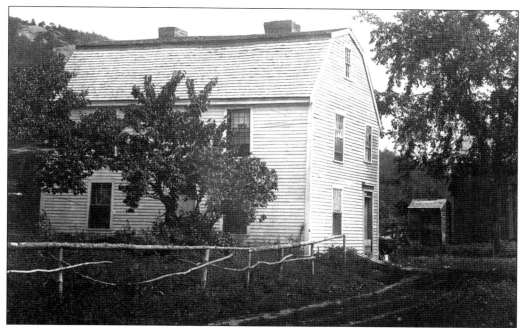

In this photograph taken about 1887 by William B. Revere, the Doty Tavern is shown just one year before it would be destroyed by fire. The tavern was built in 1737 and located at the foot of the Blue Hill. This was the location where rebels gathered in August 1774, safely out of sight of the British, to discuss the revolutionary principles that would become the Declaration of Independence. The tavern sign survived the fire and recently sold on eBay for $28,440. (Courtesy of the Canton Historical Society.)

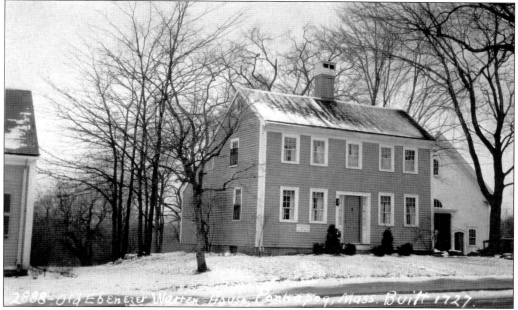

Not all historic buildings from the Colonial period have been lost. Here the Ebenezer Warren House built in 1727 in Ponkapoag is shown in an undated postcard. (Courtesy of Charles S. Crespi.)

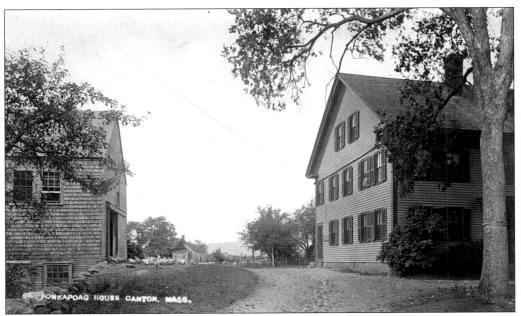

The Ponkapoag House was another popular summer resort. C. O. Tucker of Boston published this undated postcard. Today little is known about this property. Ponkapoag was the location of many resort-style hotels and allowed for great access to the countryside. (Courtesy of Charles S. Crespi.)

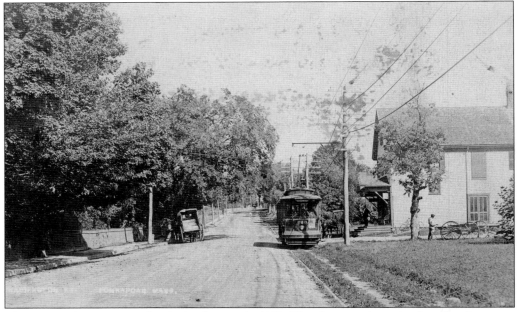

This postcard image was taken in Ponkapoag in 1910. The photograph can be dated by the poster on the front of the trolley advertising the September 3–13 Aero Meet at Harvard Aero Field in Atlantic (now Squantum). The viewer is looking north on Washington Street. On the right, the railway car is stopped at the Billings and Horton Store, which also served as the Ponkapoag Post Office and branch library. (Courtesy of Charles S. Crespi.)

This house located in Ponkapoag was built as the Cherry Hotel, reconstructed in 1839–1844 by John Gerald and Francis Sturtevant from portions of an earlier house built in 1753. This gracious house features a portico made from tree trunks. Dr. Samuel Cabot purchased the house in 1865. In 1902, it was moved to a secluded site away from route 138. In the 1980s, the apartment at the back of this house was home to NBC's Matt Lauer and his first wife, Nancy. (Courtesy of the Canton Historical Society.)

The Metropolitan District Commission's police department was created in 1893 and was the oldest state uniformed law enforcement agency in Massachusetts. This department was merged with the state police in 1992. The mounted unit was an integral part of providing safety in the Blue Hill Reservation. This postcard shows a mounted patrol in 1968. The back of the card reads, "From the Blue Hills to the Fells . . . the M. D. C. police patrol a vast park system, always ready to assist the park visitors." (Courtesy of Peter Sarra.)

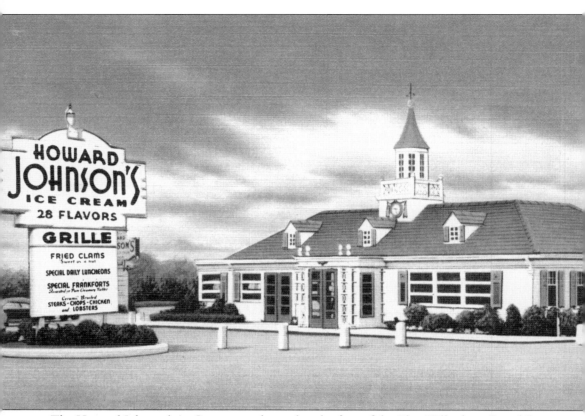

The Howard Johnson's in Canton was located at the foot of the Blue Hills along Royal Street. There is a Dunkin' Donuts in what was the original building. Here is a true piece of Americana, the roadside history that was the hallmark of the mid-20th century. In fact, the Howard Johnson's in Canton was the prototype restaurant for the chain. Originally opening in the 1930s, by 1941, this location was the test design for what would become known as the "Canton-type." Canton's Howard Johnson's was the test model for the expansion in the 1940s, and the style and interior and customer service efficiencies were all modeled at the Canton location. By October 1949, new Canton-type restaurants featured updated dining room furnishings including a new and innovative type of table that could be enlarged by a sliding panel. The table had a divider between the table opposite, and many family style restaurants continue this innovative practice still today. (Courtesy of Rich Kummerlowe.)

Two

INVITED FIRST BY HAMMER'S SOUND

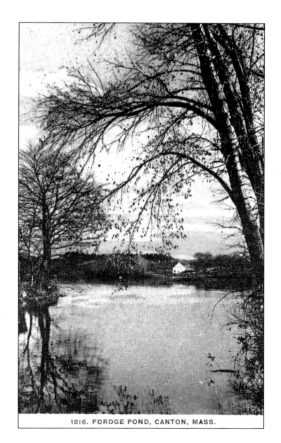

1816. FORDGE POND, CANTON, MASS.

In the mid–18th century, water was an essential tool for the development of industry. This is the site of an early gristmill and the first power loom for manufacturing cotton cloth. Here a view of Forge Pond, looking toward the Ames Shovel Shop, now the site of the Town Barn on Bolivar Street, can be seen. Lyman Kinsley built the stone shovel shop around 1845. (Courtesy of Charles S. Crespi.)

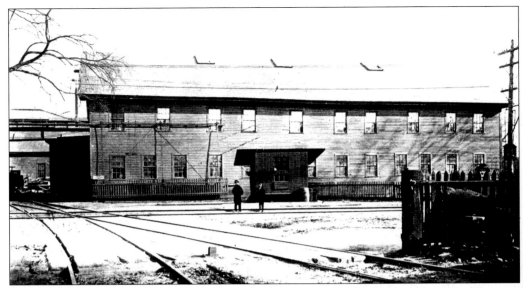

One of the most important industries was the Kinsley Iron and Machine Company. Located along Washington Street, at one point, the factory buildings spanned both sides of the street. Established in 1787 and dissolved and reformed a number of times, the firm ceased production around 1906. Early products included several thousand muskets for the War of 1812. It was the expanding American railroad industry that made this concern prosper. Over 200 men were employed at the iron works. This is an early postal card that predates picture postcards. Dated 1898, this short inexpensive message simply acknowledges a letter from the New York, New Haven & Hartford Railroad. Kinsley Iron produced wheels, castings, and axles for railroad cars as well as iron stock for rails. (Above, Courtesy of the Canton Historical Society; below, Courtesy of Charles S. Crespi.)

KINSLEY

SKIFF.

KINSLEY IRON & MACHINE CO.

Canton, Mass., .. 189

Nov.1,1898

Mr. Thomas Curtis,

Dear Sir: Yours of Oct. 28th received and we thank you for your kindness in the matter. Have taken the matter up with Mr. Scott and intend xxx calling on him Thursday. Yours truly,

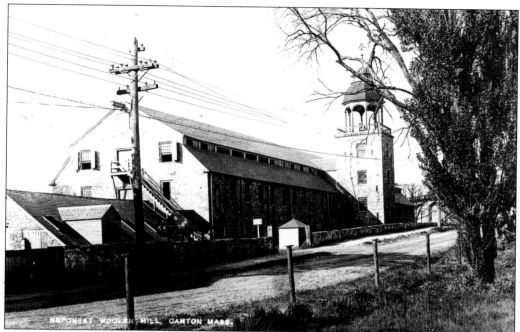

In 1802, James Beaumont, Able Fisher, and Lemuel Bailey formed James Beaumont and Company to spin cotton into candlewicks and fibers for cloth. By 1824, another group of investors built a large stone factory along present-day Walpole Street, and the name of the company became the Boston Manufacturing Company. The area quickly built up around the massive stone factory and included boardinghouses, a school, and even a medical facility. The business failed in 1827. Soon thereafter the site became the Neponset Woolen Company directed by Harrison Gray Otis, a Boston businessman, lawyer, and politician. This venture also failed, and by 1837, the site was abandoned. Over the next 170 years, many factories operated on this site, including a bleachery, a cotton factory, a wool mill, and a plastic and adhesives factory. (Above, courtesy of Charles S. Crespi; below, courtesy of the Canton Historical Society.)

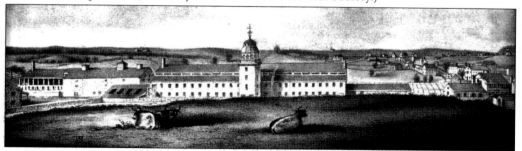

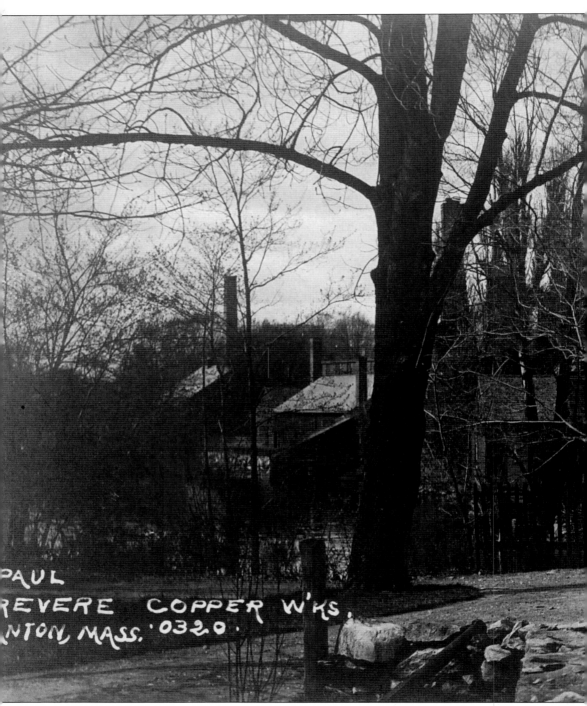

PAUL
REVERE COPPER W'KS,
NTON, MASS. 0320.

In 1801, Paul Revere began a new chapter in his life, and he chose Canton as his new home and career. Revere came to Canton to build the first copper-rolling mill in America. From this mill was produced the first and finest copper sheet metal in the fledgling nation. By 1803, Revere copper was used to line the hull of "Old Ironsides," to build the roof at New York City Hall,

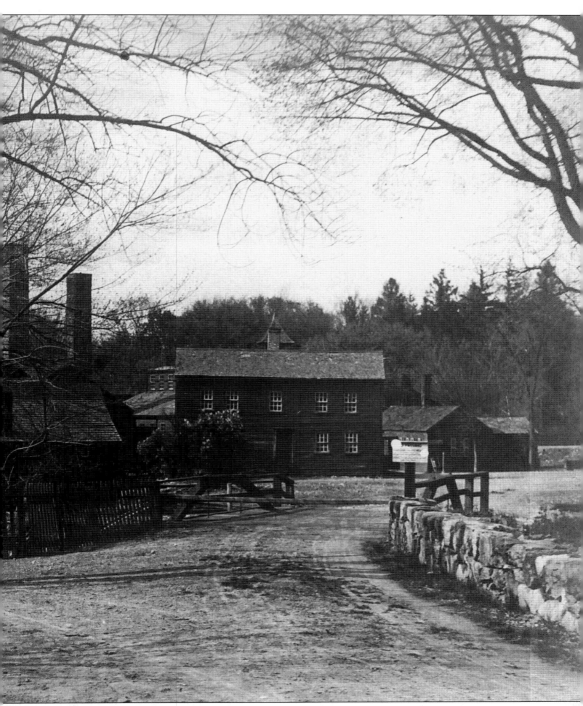

and to sheath the dome of the Massachusetts State House. Revere copper was used by Robert Fulton's famous Fulton Steamships, and more than 700 brass cannons were cast that saw action in the War of 1812 and the Civil War. This card was given to the Canton Historical Society as a gift from Margaret and Anna Revere, May 7, 1970. (Courtesy of the Canton Historical Society.)

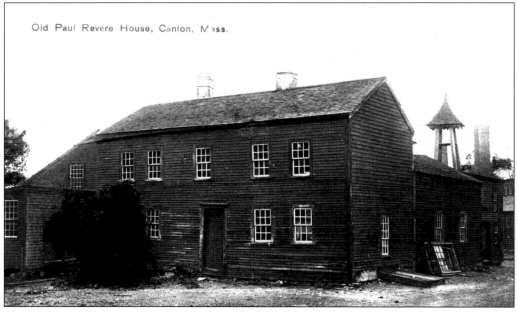

Old Paul Revere House, Canton, Mass.

On this historic site was a wood–frame house built in 1717 for "an honest miller," the townspeople seeking a person of impeccable character to mill their corn. Almost 85 years later, this simple house was the house that Paul Revere would call "Canton Dale." Placing his entire fortune on the line, Revere borrowed money from the U.S. government. If he failed, the entire fortune of his life of work would be lost. (Courtesy of the Canton Public Library, Daniel Keleher Collection.)

This is a rare interior view of the Revere house in Canton. The Revere family lived in Canton for most of the year, moving to Boston during the cold months. Revere wrote the poem "Canton Dale" in which he pens, "Not distant far from Taunton road In Canton Dale is my abode. My Cot 'tho small, my mind's at ease, My Better Half, takes pains to please." (Courtesy of the Canton Historical Society.)

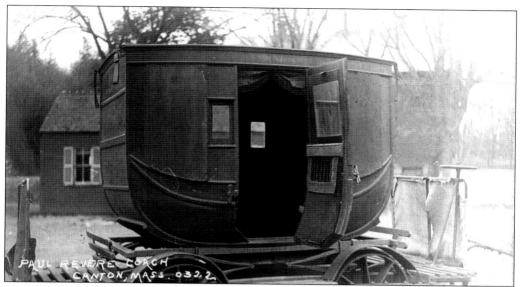

The Revere family traveled by railroad coach between the copper-rolling mill and Canton Junction. Revere lived in Canton from 1801 to 1818. This stagecoach was mounted on wheels to fit the railroad tracks and was still an artifact at the factory when it was sold at auction in 1909. The existence of this coach is unknown. This photograph was taken between 1901 and 1907. (Courtesy of Charles S. Crespi.)

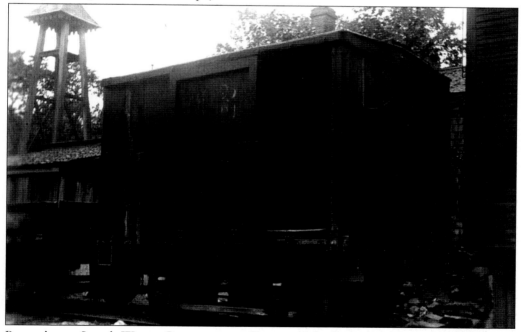

Revere's son, Joseph Warren Revere, was a director of the Boston and Providence Railroad. Revere influenced the early railroad to created a spur line into the Revere and Sons Company copper mill. This postcard shows a small railroad car used for shipping copper sheet from the mill to the railroad junction. Note the bell tower in the upper left used to summon workers to their workday. (Courtesy of the Canton Historical Society.)

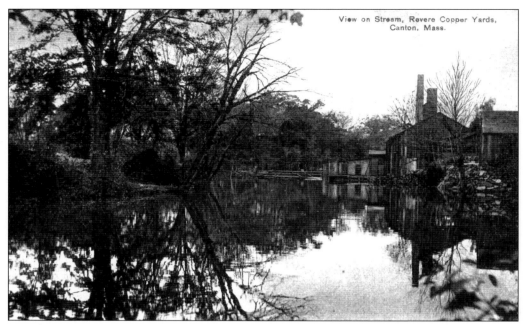

View on Stream, Revere Copper Yards, Canton, Mass.

In 1801, Paul Revere purchased a privilege along the east branch of the Neponset River. Revere was certainly familiar with this location as this was the site of the powder mill where he procured ammunition during the American Revolution. The waterpower that fueled the mill was so important to Revere and Sons that, from the beginning, he owned most of the upper and lower rights to the streams that fed the factory. (Courtesy of the Canton Public Library, Daniel Keleher Collection.)

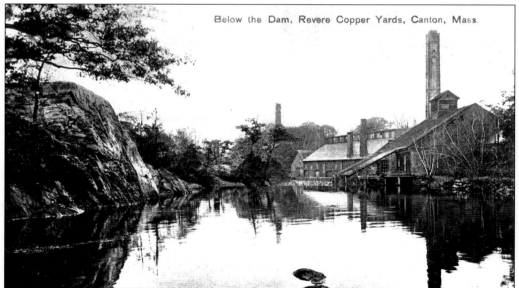

Below the Dam, Revere Copper Yards, Canton, Mass.

This view looking downstream shows the rolling mill in the distance. The brick mill is still standing on the site today. Published by Norman P. Rogers in 1908, this is a classic postcard view of the factory. There are a few versions of this card, and many are hand-colored in soft warm pastels. (Courtesy of the Canton Public Library, Daniel Keleher Collection.)

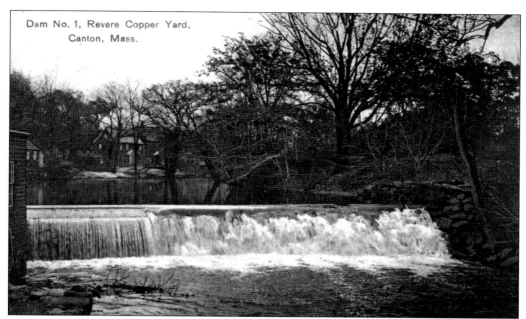

Dam No. 1, Revere Copper Yard,
Canton, Mass.

Here is another classic postcard showing Dam No. 1 at the Revere Copper Yard that was part of the set done by Rogers in 1908. During the American Civil War, the waterpower at this site enabled the rolling mill to produce one 12-pound Napoleon-style cannon per day. The contract of June 1863 was for 46¢ per pound, which made a Revere Napoleon cost about $485. (Courtesy of the Canton Public Library, Daniel Keleher Collection.)

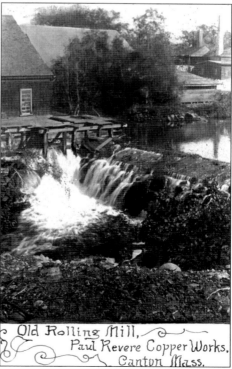

Old Rolling Mill,
Paul Revere Copper Works,
Canton Mass.

Paul Revere was known as casting the finest bells in the nation. In 1804, the Revere Bell Foundry was moved from Boston to Canton, yet the bells continued to be labeled Boston. The last known Revere bell was cast in Canton in 1843. That year, a Revere bell was sent to St. Andrews Church in Singapore by Maria Revere Balestier of Boston. The bell was in use until 1889. (Courtesy of Charles S. Crespi.)

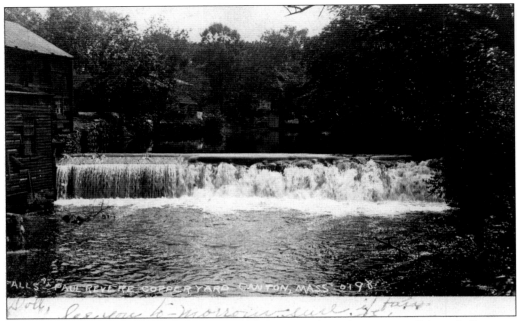

The control of water was very important for the industries along the Neponset River. A disastrous flood in August 1955 washed away the main dam and caused millions of dollars of damage to the property downstream. As a result, a new dam and sluiceway were constructed. Private contractors, under the direction of the Army Corps of Engineers, created the flood relief system. (Courtesy of the Canton Public Library, Daniel Keleher Collection.)

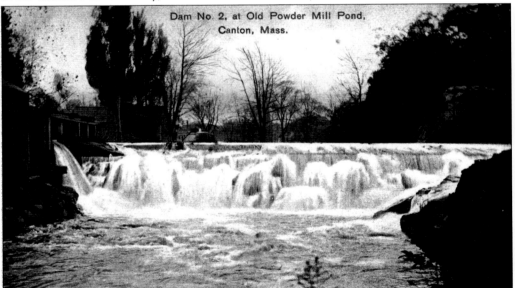

As time passed, the Revere and Sons Company found competition rising, as the demand for sheet copper declined. At the beginning of the 20th century, Revere and Sons merged with the Taunton Copper Manufacturing Company and the New Bedford Copper Company. The Canton plant was closed, and the entire factory site was sold at auction in May 1909 to the Plymouth Rubber Company. (Courtesy of the Canton Public Library, Daniel Keleher Collection.)

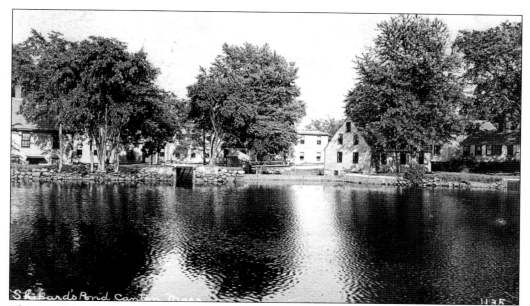

This pond has had many names associated with it, including Shepard's Pond, the Silk Mill Pond, the Third Pond, and Messenger Pond. By whatever name, it is an important center for manufacturing in Canton. It was at this location in 1834 that William S. Otis built the first steam excavator. This was also active in the manufacture of silk products from 1841 to 1903. (Courtesy of the Canton Public Library, Daniel Keleher Collection.)

In 1895, the Eureka Silk Mill was the site of a workers strike. Over 325 employees were on strike, and 175 stayed at the factory. The workers were unhappy that wages had been cut from $1 per day to as low as 65¢ per day. The mill owners had also tried to move the pay to piecework. Eventually the state intervened, and the workers returned. In 1906, the Eureka Silk Mill moved to Connecticut.

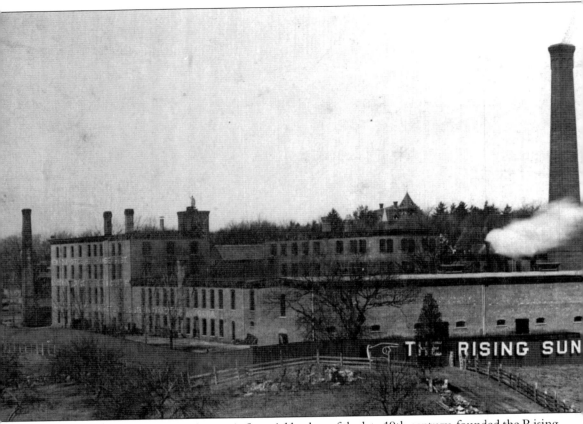

Elijah Morse, one of Canton's most influential leaders of the late 19th century, founded the Rising Sun Stove Polish Company. In 1864, Morse obtained a formula from a Boston chemist for stove polish that would shine cast-iron cooking stoves. The company imported graphite from Ceylon, India, to Canton and then created a fine powder, which would be pressed into cakes and wrapped in signature orange wrappers. The plant was situated on a four-acre site and in 1894 reportedly

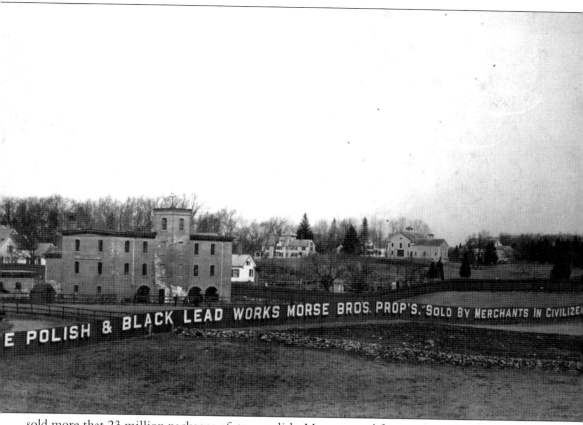

sold more that 23 million packages of stove polish. Morse served four sessions in Congress and had many influential friends, who insured his success in both business and politics. In 1878, Morse donated the land for the construction of Memorial Hall. Morse died in 1896, and his sons managed the company. By 1912, the company ceased to exist as the advent of porcelain stoves made stove polish unnecessary. (Courtesy of the Canton Historical Society.)

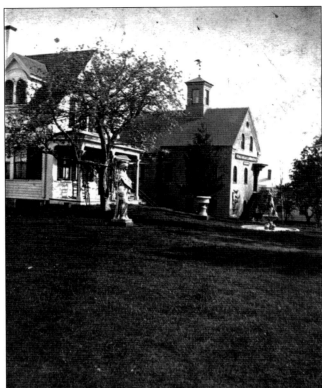

Here is a stereo-view image of the first Rising Sun Stove Polish buildings. Elijah Morse surrounded his estate and factory with statues extolling a virtuous life. Morse constructed a public watering trough because he believed in the importance of access to fresh, clean water. As a manufacturer, he was liberal toward his help, paying weekly long before such action was demanded by law. And when business declined, Morse provided employees half pay and reduced their rent.

OH! MAMMA; THAT STOVE PAINT SMELLS AWFULLY BAD AND MAKES THAT LOOK HORRID, WHY DON'T YOU BUY THE RISING SUN STOVE POLISH MRS. SMITH, USES IT AND SHE SAYS IT'S THE BEST IN THE WORLD.

What set Rising Sun Stove Polish apart from many other companies was the enormous advertising success that the brand enjoyed. Rising Sun was one of the first companies in the United States to create outdoor advertising. In the early 1870s, Morse paid to have painted advertisements on fences and rock outcroppings. The tag-line "A Thing of Beauty is a Joy Forever" was carried on posters and signs throughout the United States.

This photograph, taken by William B. Revere, shows the formidable company at the height of its importance. The caption on the reverse reads, "Rising Sun Black Lead works, Canton, Mass. New Boiler & Engine House, Chimney 125 feet high, the last brick laid in September 1886." Within 25 years, the company would cease to exist and was sold to the Enamaline Trust. (Courtesy of the Canton Historical Society.)

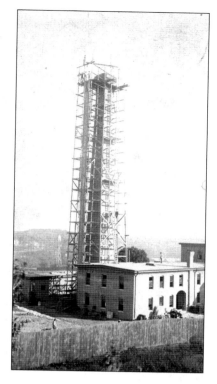

From this small product millions of dollars was amassed. Morse left a considerable fortune to his family and to charities. The Morse family stayed active in Canton affairs well into the end of the 20th century. The land for the expansion of Canton High School was a gift from the family. In 1989, Mildred Morse Allen left 138 acres of land and estate buildings to the Massachusetts Audubon Society. (Courtesy of the Canton Historical Society.)

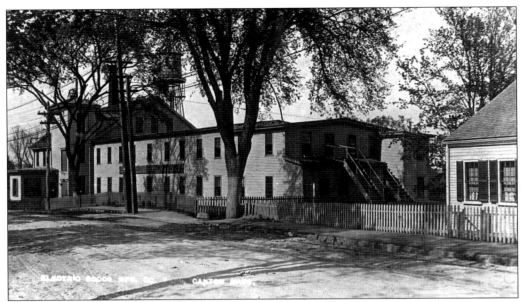

Samson Electric Company moved from Boston to Canton in 1907 and took up the factory buildings vacated by the Eureka Silk Company. Known as the Electric Goods Company, they manufactured home telephones, speaking tubes, fire alarm systems, and liquid batteries. By 1916, they pioneered the radio industry with "wireless receivers." These were headphones for wireless radios consisting of brass circles formed into a cup and then nickel-plated. The two magnets and the fine wire coils were assembled by hand. The *Canton Gazette* of April 7, 1922, reported that at the Samson Electric Company, "Girls were hired to do the final assembly work and were paid $12 to $14 a week." Samson was very diversified; they also made Perfex. The Perfex ignition system was waterproof and was widely used in marine and automobile applications. (Above, courtesy of Peter Sarra; below, courtesy of the Canton Public Library, Daniel Keleher Collection.)

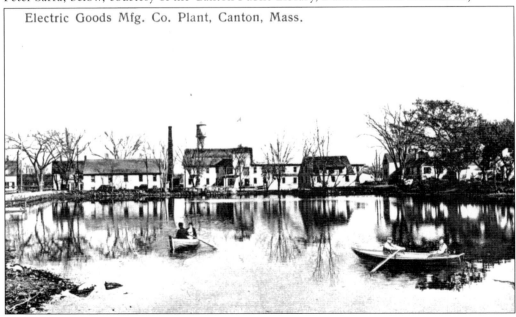

Electric Goods Mfg. Co. Plant, Canton, Mass.

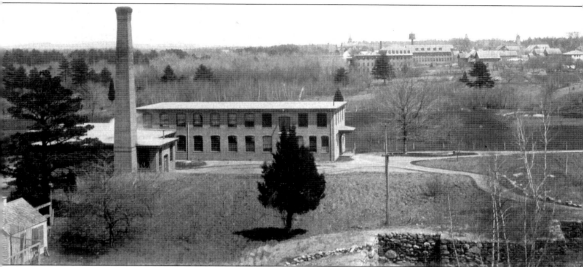

George Sumner started the Knitted Mattress Company in 1880. The Queen Anne–style factory building, constructed around 1890, is located just on Chapman Street and is still standing. Knitted Mattress manufactured specialized padding for tables, stairs, car seats, church pews, and mattress springs. Sumner had been a partner of James Draper, and the enterprises in the vicinity all coexisted in a climate of prosperity. By the end of the 19th century, there were more than half a dozen small producers of knit goods. An 1898 advertisement extolled the virtues of the knitted table pads, "they represent the difference between Good housekeeping and Bad housekeeping,—the difference between Comfort, Economy, and Luxury, and Discomfort, Extravagance and Drudgery." Who knew knitted table pads could be so important? This photograph shows the Sumner's Knitted Mattress Company in the foreground, and the Draper mill complex is in the distance. (Courtesy of the Canton Historical Society.)

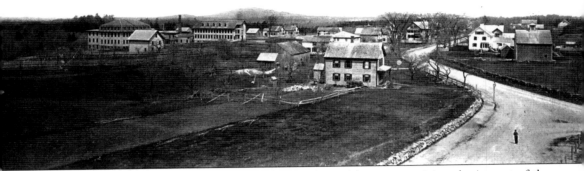

No description of the industry in Canton is complete without recognizing the impact of the Draper family. This photograph shows the intersection of Chapman Street and Washington Street. To the far left is the Draper mill complex as it appeared in the late 1800s. Draper Knitting Company is one of the oldest textile mills in the United States. The company, begun by James and Thomas Draper in England, began manufacturing in Canton in 1851. Canton Woolen Mills opened at the corner of Washington and Pleasant Streets. The small house where it began is still standing. Thomas died in 1856, and James died in 1873. James's children began running the business, and in 1889, they incorporated Draper Brothers Company. For over 150 years, the Draper family and the Draper mills have been an integral part of the community. Today known as Draper Knitting Company, it is operated under the direction of a fifth-generation Draper. Draper Knitting Company is the only company in the United States that produces three types of fabric formation under one roof. (Courtesy of the Canton Historical Society.)

Three

A Record of Progress

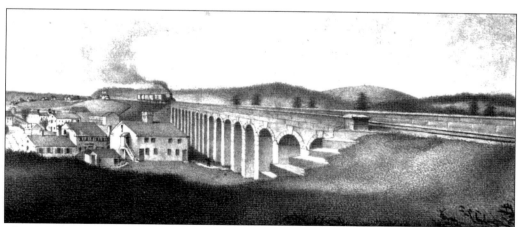

The real measure of progress as a community came with the advent of the railroad. Begun in 1832, the Boston and Providence Railroad would forever change the town through the development of a robust industrial base and a connection on the direct line between Boston and New York. This a detail of the view of West Village in Canton, engraved by Ephraim W. Bouvé. (Courtesy of the Canton Historical Society.)

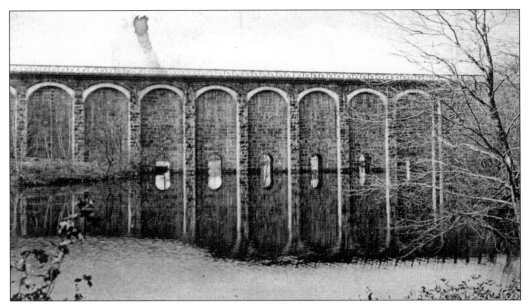

The Canton Viaduct is the most photographed postcard of all the Canton landmarks. This early view shows the eastern side of the bridge with the factory pond in the foreground. The viaduct was built in 1835 at a cost of $93,000. Built principally by Irish laborers and Scottish stone Freemasons, they labored for more than 15 months to complete the massive structure.

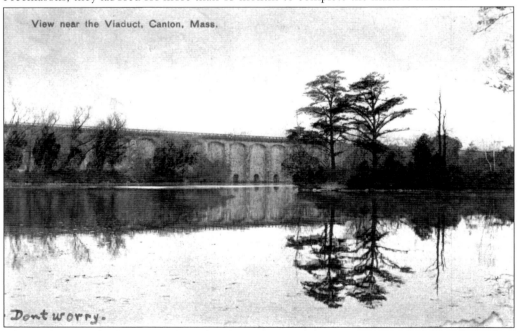

The viaduct was built to span the vale of the Canton River, the east branch of the Neponset River. Paul Revere's son Joseph Warren Revere was on the board of directors of the Boston and Providence Railroad, and he had considerable influence to insure that the fledgling rail line passed within striking distance of his copper and rolling mill at Canton. This view was taken from the Revere property and was postmarked in 1908.

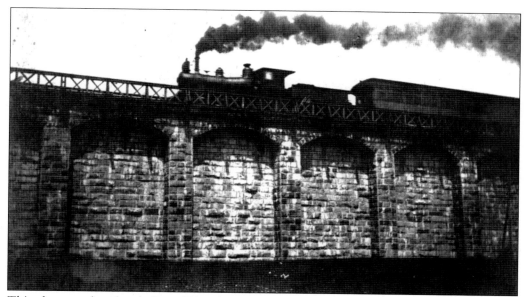

This photograph, taken in June 1892, demonstrates the impressive sight of a steam locomotive passing over the viaduct. Designed by Capt. William Gibbs McNeill and Maj. George Washington Whistler, it was built by Dodd and Baldwin. The stone bridge is unique as there are no others like it in America and perhaps as few as two others in the world. It has long been speculated that the two sister bridges are on the Moscow–St. Petersburg Railway. (Courtesy of the Canton Historical Society.)

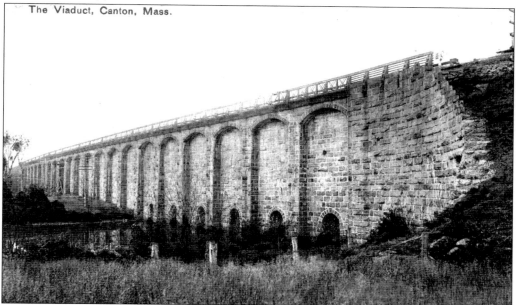

The Viaduct, Canton, Mass.

Another eastern view of the viaduct shows the full extant of the stone arch bridge. The entire bridge is 615 feet long and built with a one-degree curve. Each facing stone has a mason's mark to identify the mason who cut the stone. The wall facing stone, wing wall abutments, arches, coping, parapets, and cornerstone were quarried at Moyles Quarry in Sharon. The wall backing stone, foundation, deck, and interior buttresses are granite from Dunbar's quarry in Canton.

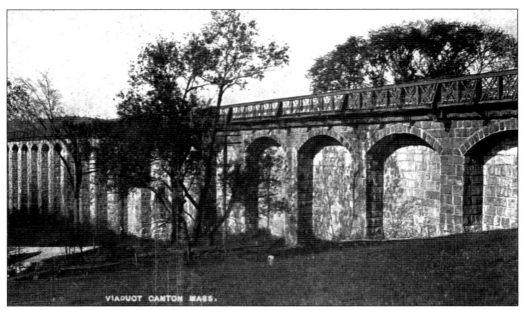

The postcard view (above) of 1919 was taken from the hill overlooking Walpole Street just above the roadway arch. When the viaduct was built, it only had one archway for traffic. Given that the traffic of the day was largely horse and carriage, it would take 118 years for the second archway to be cut into the structure. Many large vehicles still maneuver with great difficulty through the smaller concrete arch cut in 1953. The photograph below shows the east side of the viaduct as Neponset Street passes under the bridge. In 1786, the way leading from the Stone Factory Village to Washington Street under the what would become the viaduct was called Billings Lane, after William Billings II. In 1790, Billings Lane became known as "Ye Road from Ye Schoolhouse on Taunton Road to Ye Old Forge," eventually changing to Neponset Street. (Below, courtesy of the Canton Historical Society.)

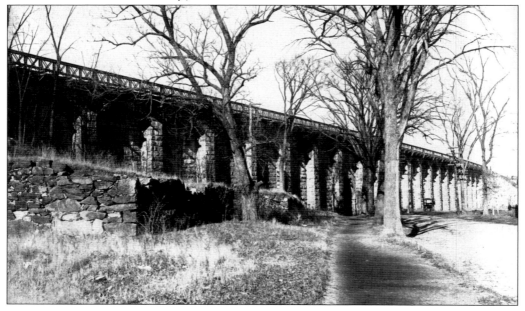

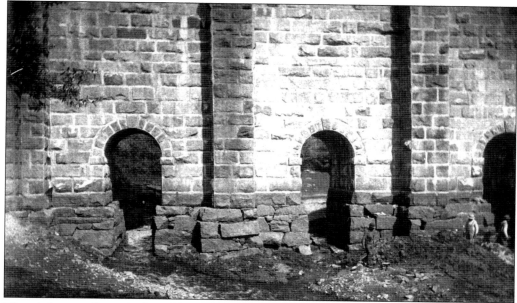

The viaduct performed admirably for 70 years, but railroad equipment kept getting faster and heavier. Originally designed for a single locomotive, the bridge was altered in 1860 to allow for a second track. By 1897, problems began appearing. The view above shows workers repairing the foundation of the viaduct after diverting the Canton River significantly to expose the footings. The postcard view of 1906 (below) shows heavy supporting timbers where arch stones had begun to deteriorate due to heavy loads and harsh weather. By 1909, a deck stone dropped and the future of the viaduct was uncertain. In 1910, concrete reinforcement of all 42 arches began, and it took 29 months to complete. In 1993, major renovations widened and electrified the deck and reinforced the stone arches and buttresses using improved methods that were not available in the early 20th century. (Above, courtesy of the Canton Historical Society.)

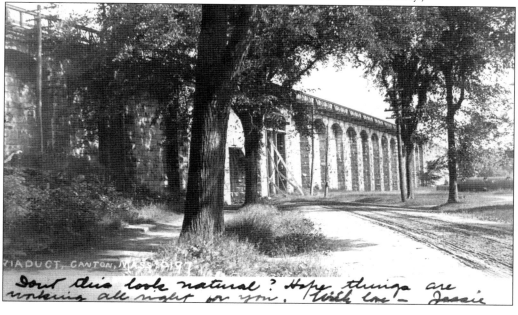

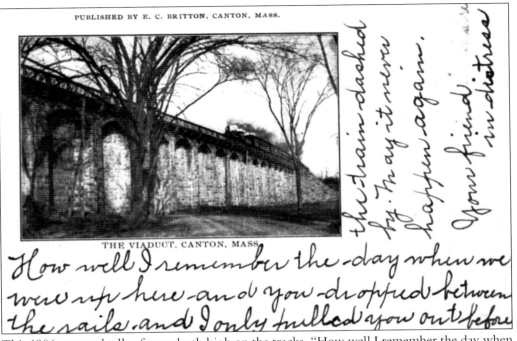

PUBLISHED BY E. C. BRITTON, CANTON, MASS.

THE VIADUCT, CANTON, MASS.

the train dashed by. May it never happen again. Your friend in distress

How well I remember the day when we were up here and you dropped between the rails and I only pulled you out before

This 1906 postcard tells of near death high on the tracks. "How well I remember the day when we were here and you dropped between the rails and I only pulled you out before the train dashed by." While people have been killed on the viaduct, this has been a rare occurrence. A wooden fence was installed in 1860, and a modern steel fence has been maintained since 1880. (Courtesy of the Canton Public Library, Daniel Keleher Collection.)

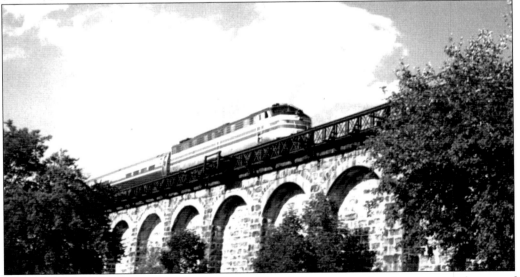

Today the Canton viaduct is as vital as ever. The viaduct was updated to support the use of high-speed electric trains and Amtrak's signature *Acela Express* maintains speeds of over 100 miles per hour over the superstructure. This is a modern postcard view showing the outbound *Liberty Express* as viewed on the Canton Viaduct in Canton on June 21, 1980. (Photograph by Stephen Dunham.)

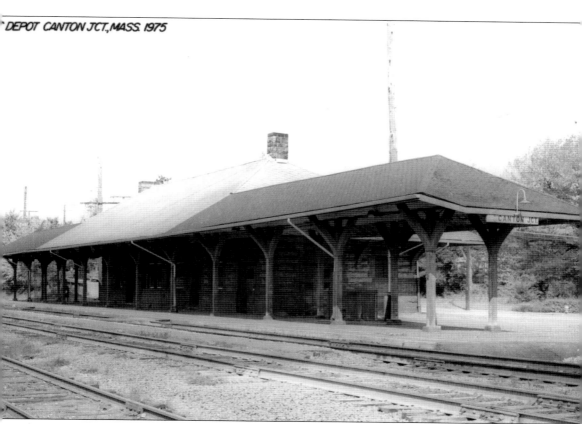
DEPOT CANTON JCT, MASS. 1975

Located less than a quarter of a mile from the Canton Viaduct is Canton Junction. A train station has been on this site since the early 1800s. The present station was designed by Bradford Lee Gilbert and built in 1892. The scene even 50 years ago is vastly different than that of today. The junction was the focal point of the community for both social and economic reasons. Immigrants would arrive from Boston and New York, and the junction was their stepping off point. Soldiers left here for all of the wars, and some never returned. The coal sheds, water tower, signal towers, turntable, and multiple spur lines are all gone. The mail no longer comes through the station, and platforms that once bustled with shipments from around the world are largely quiet. Today the junction is a bustling commuter station that delivers thousands of people to South Station each week. The station survives because it is still relevant and part of the daily needs of a growing community. (Courtesy of Charles S. Crespi.)

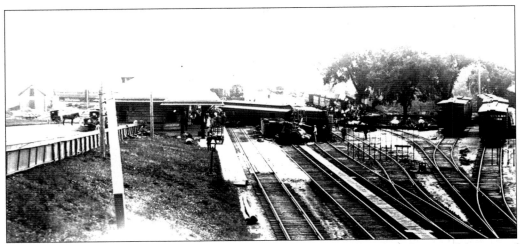

On Monday, August 8, 1898, a resounding crash brought hundreds of residents to the scene of a fatal crash that involved train 70, the Boston Bound Mail Train. The train, carrying 14 mail clerks and comprised of four cars, left New York City at 11:30 p.m. Sunday night. As the train approached Canton Junction, in an instant the cars slammed off the track. The train plowed toward Canton Junction, and the speed caused them to quite literally dig into the stone track bed. Three men were killed and 14 mail clerks were injured. The clerks described being "tossed around like dice" in the railroad cars. It took some time to rescue the clerks, and the dead men were extracted late the same day. These photographs were taken by Fred Endicott and W. Ames. (Courtesy of the Canton Historical Society.)

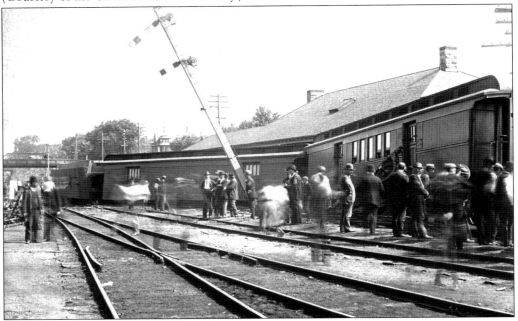

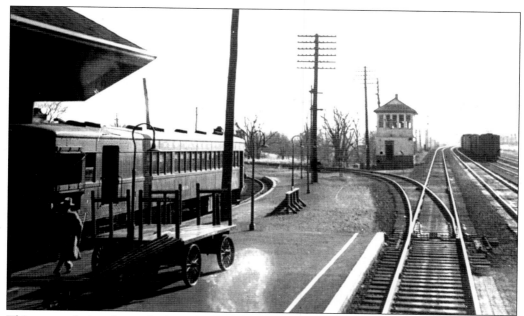

This postcard view shows the Stoughton Branch inbound and outbound platform looking toward the viaduct. The large signal station (wooden tower) was identified as SS-178 and was manned to insure that switches were thrown properly at the junction. This photograph was taken in 1948, and the station was part of the New York, Hartford and New Haven Railway. (Courtesy of Charles S. Crespi.)

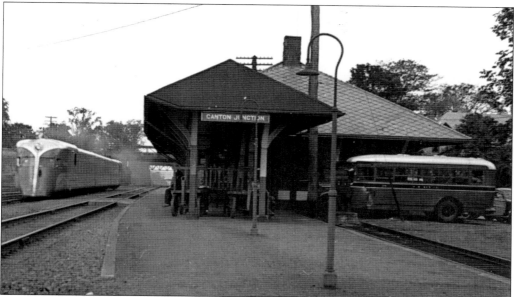

This postcard was photographed on October 4, 1941, and shows No. 9200, the Comet roaring through the junction. It was built in 1935 for the New York, New Haven, and Hartford Railroad by Goodyear Zeppelin Company. The schedule read, "44 miles in 44 minutes" with a fare of $1.75. Aluminum skinned with tubular steel frame, it was painted in a striking blue and white. The train was scrapped in 1951. (Courtesy of Charles S. Crespi.)

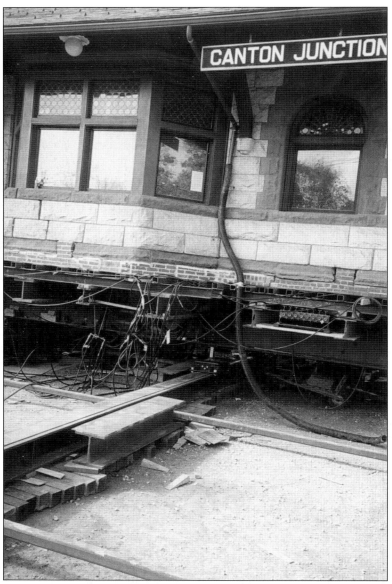

As technology allowed for faster and lighter trains, Canton Junction and the viaduct had to adapt. In order to achieve a dedicated high-speed rail service between Boston and New York, Amtrak needed to upgrade the tracks and create additional capacity free from the constraints of local commuter traffic. The viaduct underwent enormous structural renovations to allow for the installation of a catenary system to provide power to the engines of the bullet-style trains. At Canton Junction, this meant physically picking up the station and placing it on a new foundation to pave the way for new tracks. In the fall of 1999, the International Chimney Corporation lifted the junction, set it on tracks, and slid it into place on a new foundation. The entire station, including its 189-foot-long canopy, was moved in one piece. The move path consisted of moving the station back away from the tracks, rotating the station, then moving the station sideways to its final location. One would never know when visiting there today. (Courtesy of the Canton Historical Society.)

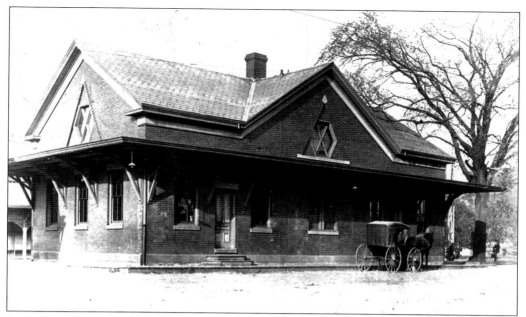

In Canton Center stood this grand building. Canton Station was built in 1880 to serve the Stoughton Branch Railroad at South Canton. The Stoughton Branch Railroad was chartered in 1844 to create a connection between Stoughton and the Canton depot of the Boston and Providence Railroad. The postcard above shows a 1910 view of the front facing side with Washington Street on the right. (Courtesy of Charles S. Crespi.)

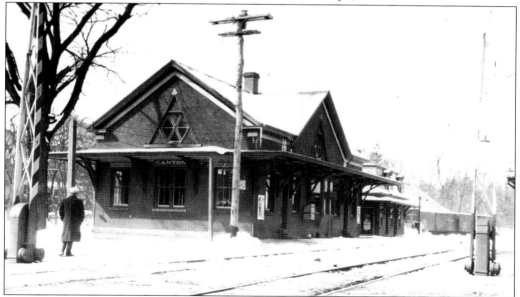

The distance between the Stoughton station and Canton Junction was four miles, and the railroad cost $80,000 to build. Commuters used this depot until February 1949. While there were likely previous stations near this spot, no photographs seem to have survived. The postcard of the winter scene shows the track side and crossing at Washington Street and dates to 1928. (Courtesy of Peter Sarra.)

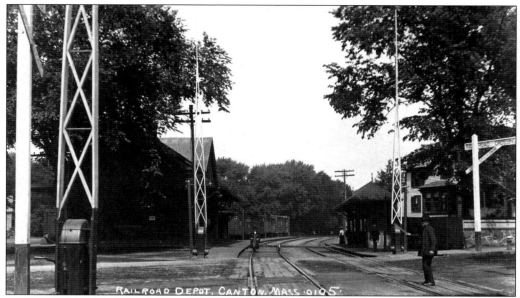

RAILROAD DEPOT, CANTON, MASS. 0105

This wonderful scene of the early 1900s shows the gates at Canton Station. On the right is the flagman who has stopped traffic. If one looks closely, a trackman can be seen on a velocipede riding the rails, and just under the canopy to the right are several well-dressed ladies awaiting the train. Flashing lights and warning gates were installed in 1948. (Courtesy of the Canton Public Library, Daniel Keleher Collection.)

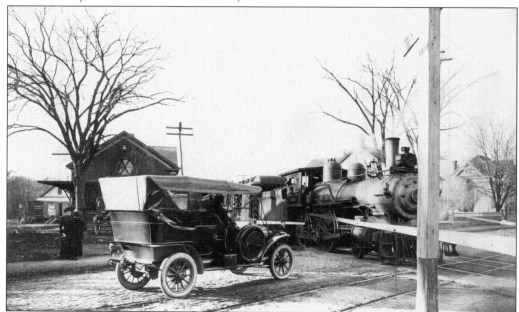

No less charming is this 1910 view of technology at its finest. Horseless carriage meets the iron horse at the gates of the Canton Station railroad crossing on Washington Street. The station was closed in February 1949. According to local railroad historian Ed Galvin, a variety of tenants used the building, including the Knights of Columbus and a Christmas tree stand. The building was demolished in 1959. (Courtesy of the Canton Public Library, Daniel Keleher Collection.)

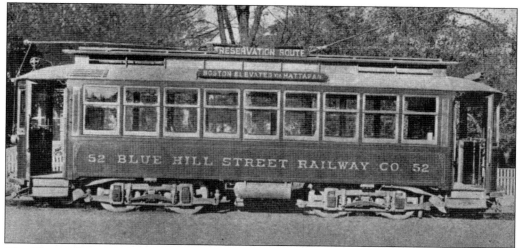

The Blue Hill Street Railway was a small independent company. Principally owned by the engineering firm of Stone and Webster, it had close ties to many prominent Canton businessmen including Forbes, Huntoon, Chapman, French, Endicott, and Rogers. Chartered in 1899, it would never show a profit and a fortune would be lost working to maintain the equipment and the 15-mile line from Mattapan to Canton. (Courtesy of the Canton Public Library, Daniel Keleher Collection.)

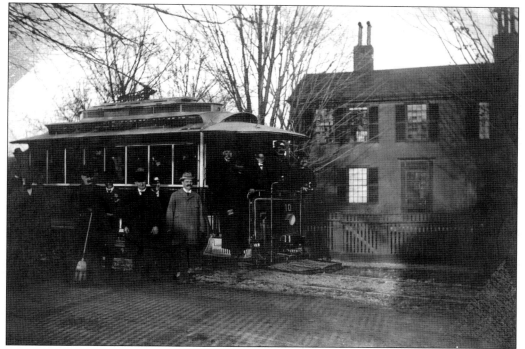

This is a photograph of the first railway car as it passed from Canton Corner to Ponkapoag, at Crowell's Corner, December 1, 1899. In the foreground is Joseph Wattles II (in grey coat and hat). During the first five years of operation, the basic fare was 5¢; over time and as the routes expanded, zones were introduced, and the fares increased. (Photograph by Frederick Endicott, courtesy of the Canton Historical Society.)

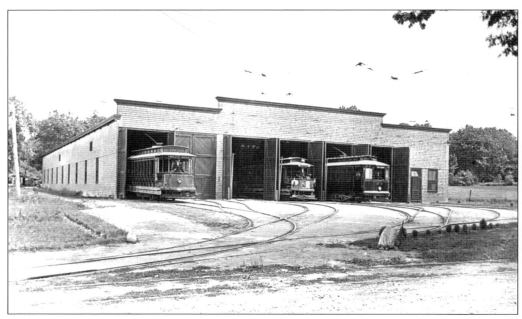

This postcard shows the new car house at Cobb's Corner that was built in 1909. The car house was 150 feet long and 100 feet wide. The facility had a capacity for more than 16 trolleys. A massive fire destroyed this building in 1921. Along with most of the trolleys, a number of new Oldsmobiles, owned by a local dealer, were destroyed. (Courtesy of the Canton Public Library, Daniel Keleher Collection.)

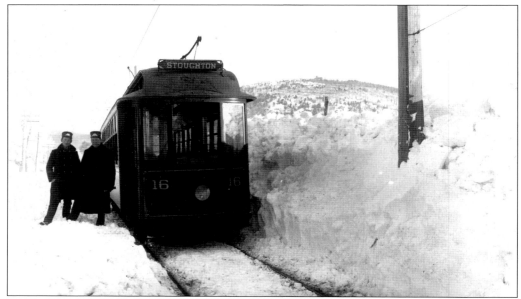

The end came to the railway at the hands of Mother Nature. Operating losses were significant. In the winter of 1919–1920 severe storms forced the suspension of service, and lost parts that would have repaired a steam cylinder at the powerhouse arrived late. Power stations ran out of coal in a February storm, and cars stayed stranded for a month or more. This photograph is from 1902–1903, with the Great Blue Hill in the background. (Courtesy of the Canton Historical Society.)

Four

Pro Bono Publico

As the town grew and wealth and influence gathered, many new buildings were constructed at the beginning of the 20th century. To serve the burgeoning immigrant families, new schools were constructed. To serve the needs of a modern community, Memorial Hall was built. To feed the mind, the public library was built. And to take care of those in need, the Massachusetts Hospital School was founded. Great ideas helped build great buildings and institutions. (Courtesy of Charles S. Crespi.)

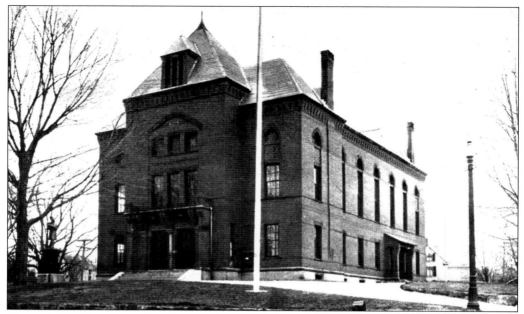

Memorial Hall was completed in 1879 on land donated by Elijah Morse. It was designed by Stephen C. Earle of Boston and Worcester. The building exemplifies a time when historical revival was the mainstay of both civic and architectural sensibilities. Earle was a prominent designer of public buildings. As evident in the design of Memorial Hall, rural English Gothic churches inspired much of his work. (Courtesy of Charles S. Crespi.)

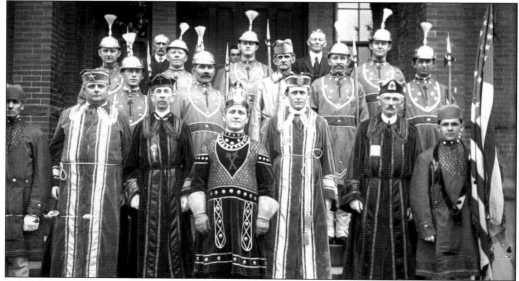

For over 130 years, this building has served the community. When it opened, the first floor was used as the public library and the offices of the selectmen, town clerk, and treasurer. The second floor was a public hall and accommodated more than 1,000 people. Heralded as a community center, many notable events, discussions, celebrations, and performances happened here. This early photograph from a glass plate shows actors posing on the side steps. (Courtesy of the Canton Historical Society.)

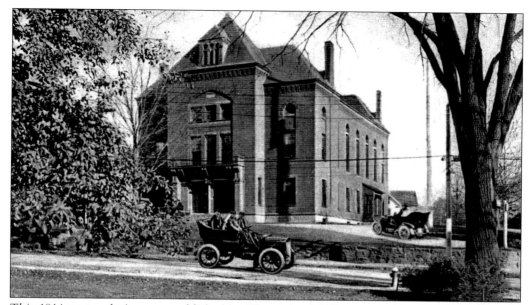

This 1914 postcard view was published by Thomson and Thomson of Boston and printed in Germany. This postcard was part of a series showcasing many of Canton's civic and landmark sites. The clock was salvaged from the Congregational church in 1969 when the church was demolished. (Courtesy of the Canton Public Library, Daniel Keleher Collection.)

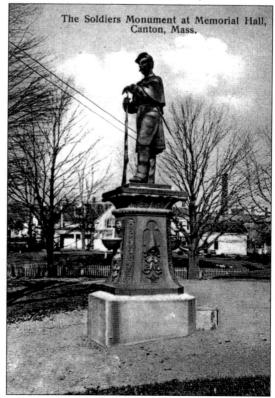

This postcard, postmarked in 1915, shows the Civil War Soldiers Memorial on the pedestal outside Memorial Hall. Donated by Elijah Morse, this statue, fountain, and pedestal were originally installed in the vestibule of the hall. Morse offered to pay to have the bronze monument moved outdoors atop the steps leading from Washington Street to Memorial Hall. After severe vandalism, the statue was repaired and moved indoors in the early 1970s. (Courtesy of Charles S. Crespi.)

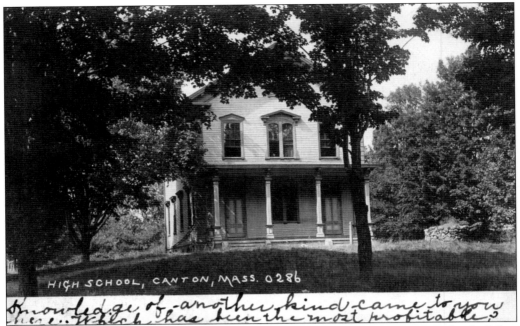

The first high school was located along Washington Street. The two-story wooden building (above) was built in 1869 after 11 years of petitions. The building cost $10,000 to construct after much controversy as to the location. This 1906 postcard was sent to Amy Downes, and reads "Knowledge of another kind came to you here. Which has been the most profitable?" (Courtesy of the Canton Public Library, Daniel Keleher Collection.)

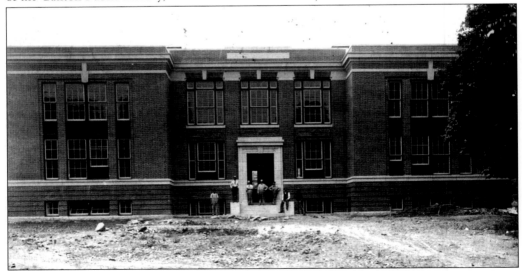

Augustus Hemenway, a wealthy philanthropist, lived in a mansion on Green Street. In 1893, Hemenway sent every teacher in Canton to the World's Columbian Exposition in Chicago at his own expense. In 1894, Hemenway built a new school in Ponkapoag. The children started a fund, and soon the contribution box "held many a grimy nickel and polished cent." Hemenway contributed $20,000 to help build the new high school, shown nearing completion in this 1911 postcard. (Courtesy of Peter Sarra.)

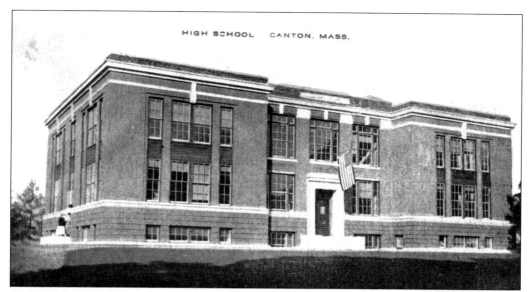

HIGH SCHOOL CANTON, MASS.

By 1910, the search for a suitable location for the new high school was narrowed down to a few choice properties. The town decided to build on the four-acre estate of the late Frank M. Ames. Ames moved to Canton in 1858 from Easton to take control of the business of the Kinsley Iron and Machine Company. His chief interest was railroads, and he was for several years sole trustee and manager of the New Orleans, Mobile and Texas Railroad. He also owned a large plantation of about 12,000 acres on the Mississippi River. Ames was Canton's representative to the general court, and in 1884, he was elected to the Senate. The central location for the new high school was a great choice. (Above, courtesy of the Canton Public Library, Daniel Keleher Collection; below, courtesy of the Canton Historical Society.)

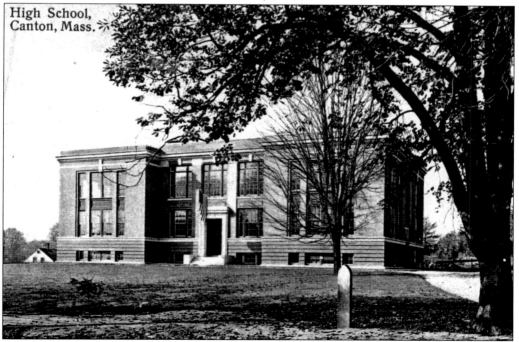

High School, Canton, Mass.

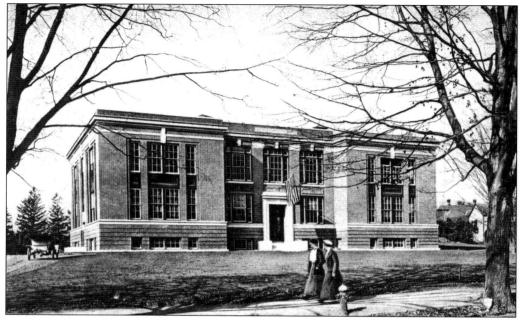

By 1947, postwar Canton was booming. More space was needed for schools, and the town decided to turn the high school into the Hemenway Elementary School. The elementary school was closed at the end of the 1981 school year. In 1979, the Canton Housing Authority was awarded $1.9 million to construct the town's third elderly housing project. In 1983, the Hemenway Housing Complex opened to great reviews. (Courtesy of the Canton Public Library, Daniel Keleher Collection.)

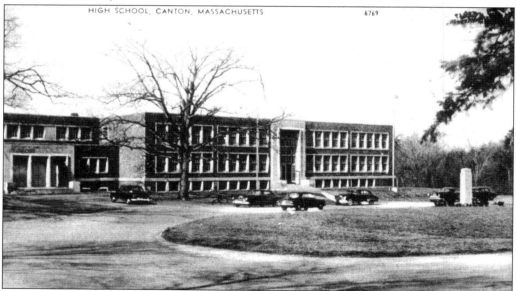

The "new" high school was constructed in 1947 and was used as part of an ever-expanding high school. Extensive renovations and expansion at this site have yielded a modern and superb facility that is among the finest schools in the Commonwealth of Massachusetts. (Courtesy of the Canton Public Library, Daniel Keleher Collection.)

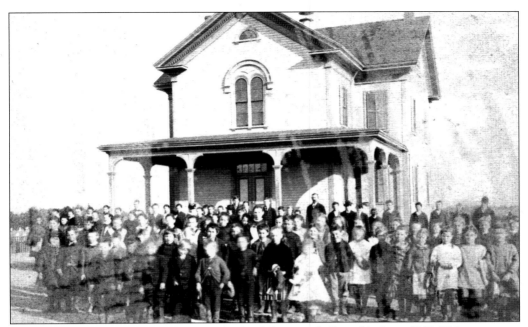

This is a stereo view of the original Eliot School that was dedicated in June 1867. This two-story building measured 30 feet by 14 feet and was built at the intersection of Washington and Randolph Streets. In 1882, the building was moved to a site near the parish hall of the First Congregational Church. Faced with significant overcrowding, as demonstrated in this photograph, this building was demolished around 1894. (Courtesy of the Canton Historical Society.)

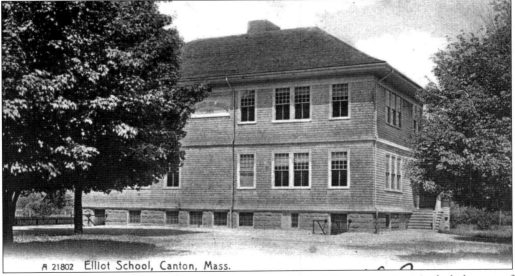

A 21802 Elliot School, Canton, Mass.

The second Eliot School was constructed in 1894. The building committee included some of Canton's most influential citizens such as Francis Dunbar and Joseph Wattles. A local company, J. F. Stone and Company, constructed the new school. This school had unusually large windows, which allowed generous amounts of sunshine and air to enter the classrooms. In 2004, after extensive renovations and a large addition, the building was opened as Canton's new police station. (Courtesy of the Canton Public Library, Daniel Keleher Collection.)

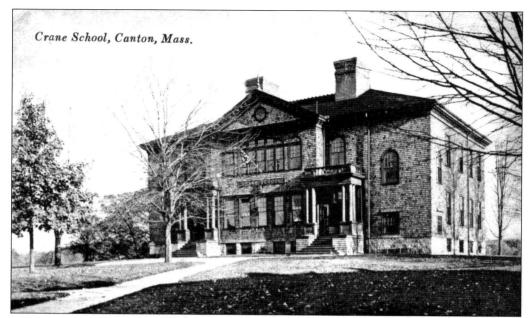

Crane School, Canton, Mass.

The Crane School stood in Canton Center at the intersections of Washington and Bolivar Streets. The building was dedicated in 1854, and it was declared at the time as "unequalled in beauty of architecture and completeness of design." The loss of the building was a contentious issue at town meeting, and people still bemoan the loss of such a beautiful wooden structure. (Courtesy of Peter Sarra.)

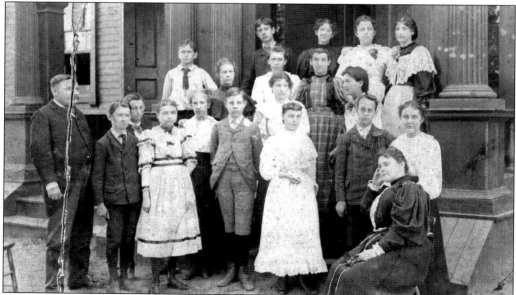

When the Crane School opened, in addition to grades one through eight, it introduced advanced studies to post–eighth–grade students. In April, members of the class of 1869 were the first to receive their diplomas from high school, and they received their entire high school education at the Crane School from one teacher, H. B. Miner. The first graduating class consisted of six members, all young women. (Courtesy of the Canton Historical Society.)

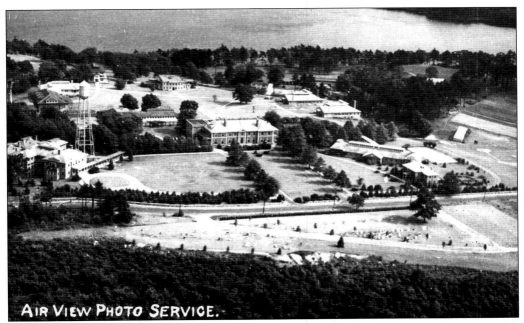

AIR VIEW PHOTO SERVICE.

Here is a 1938 aerial postcard showing the extensive grounds and facilities of the Massachusetts Hospital School (MHS). At the center is the administrative building, and the water town that supported the vast complex is on the left. In the background, Reservoir Pond forms the boundary of the state-owned property. (Courtesy of Charles S. Crespi.)

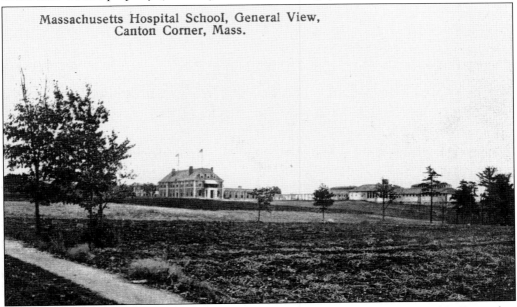

Massachusetts Hospital School, General View, Canton Corner, Mass.

Originally established in 1904 by the Massachusetts legislature, the MHS opened in December 1907. Up until this time, children who were not considered physically "normal" were often denied an education. Also, the lack of medical knowledge needed to treat or even alleviate many conditions left children to suffer excruciating pain both physically and emotionally before dying at an early age.

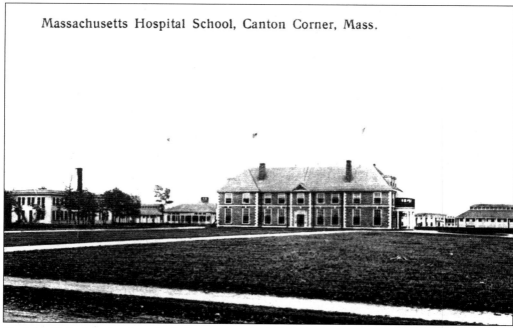

Massachusetts Hospital School, Canton Corner, Mass.

Dr. John Fish played a pivotal role in creating the MHS. As the superintendent for over 40 years, Fish was responsible for managing the pioneering care of young patients. The school was a model for supportive institutions around the world. By 1920, it was firmly established and creating occupational programs for students that would transform their lives and help them become part of a greater society. (Courtesy of the Canton Public Library, Daniel Keleher Collection.)

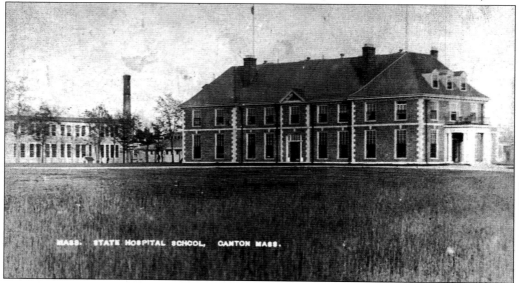

This 1910 postcard shows the administrative building of the MHS that was founded by Dr. Edward H. Bradford. By 1924, Harvard University was affiliated with the MHS, and in the ensuing decades, the Canton campus hosted the North American and European medical communities whose members came to witness the intricate and groundbreaking orthopedic surgery that was routinely taking place. (Courtesy of the Canton Public Library, Daniel Keleher Collection.)

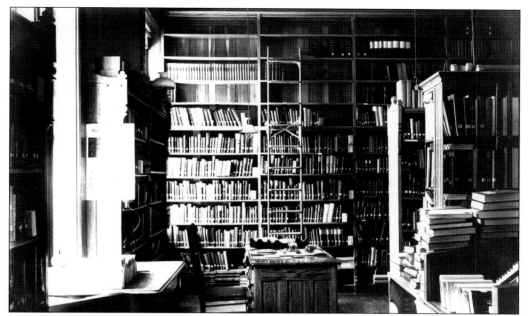

Canton's public library found a new home in 1879 in the newly constructed Memorial Hall. While Memorial Hall served as a seat of government, it also was a true community center, and the library located on the first floor played a prominent role in the development of the community. This photograph shows the burgeoning shelves of the library that outgrew its space by 1901. (Courtesy of the Canton Public Library.)

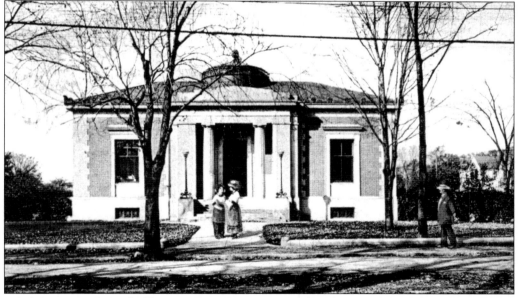

While begun in 1874, the library received its permanent building as a gift in 1901. The building and grounds were bequeathed to the Town of Canton by Augustus and Harriet Hemenway, Canton philanthropists, "in consideration of [the] desire to promote the study of Science, Literature and Art in the Town of Canton, and for other good and valuable considerations." (Courtesy of the Canton Public Library, Daniel Keleher Collection.)

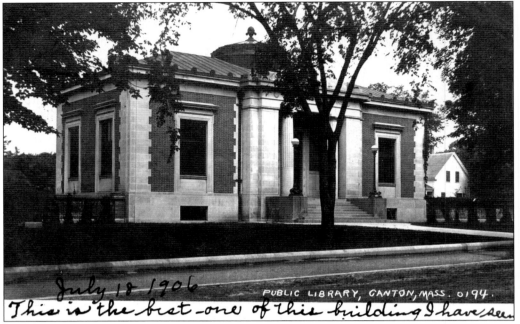

The caption on this 1906 postcard reads, "This is the best one of this buildings I have seen." And indeed, the new library was a spectacular addition for the town. Designed after the Harvard or "Old English bond" style, it was built by architects Winslow and Bigelow for $70,000. It opened on July 6, 1902. (Courtesy of the Canton Public Library, Daniel Keleher Collection.)

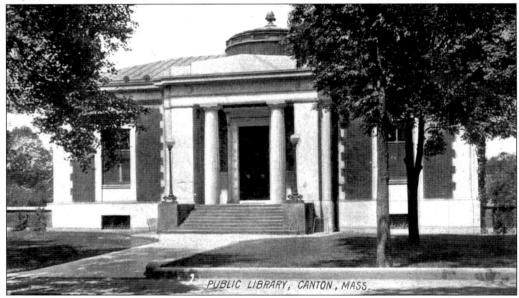

The new library was inspiring. A glass dome soared over the marble floors. Columns were topped with bronze capitals, and sandstone fireplaces graced the reading rooms. Designed to be a temple to learning, from day one it became an institution. It was so supportive of education that some individuals studying for college had a key to the lower meeting room to study after hours. (Courtesy of the Canton Public Library, Daniel Keleher Collection.)

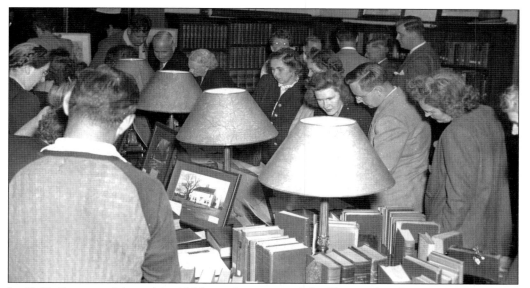

In 1947, Canton celebrated its 150th anniversary, and the library played center stage with an exhibit that engaged hundreds of Canton residents. The Canton Public Library has long been the center of community activities and has strong ties with the Canton Art Association and the Canton Garden Club. (Courtesy of the Canton Public Library.)

By the 1960s, the town had outgrown the library in its present form. The needs and courses of study had shifted from recreational to educational interests. More space was needed to accommodate special collections and for an adequate children's room. The wisdom of the Hemenway's gift of such a large tract of land in the center of the downtown became apparent as expansion plans were pursued.

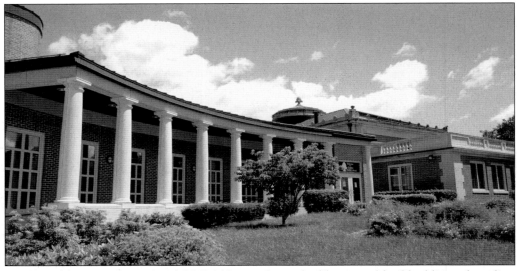

In 1962, the town appropriated $261,000 to enlarge the library and build additional reading rooms and book stacks. The library grew from 7,000 to 17,000 square feet. Within 38 years, the 1962 addition was removed, and an aggressive new $9.7 million library was added around the original structure. The library reopened on June 23, 2002.

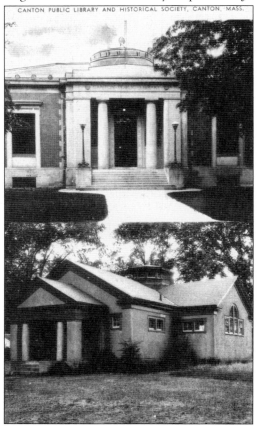

Close connections between the Canton Public Library and the Canton Historical Society have always been a part of the growth of both institutions. Many society trustees and library trustees have served passionately within both cultural institutions. Katherine Sullivan, Edward Bolster, Daniel Keleher, as well as members of the Capen, Draper, Endicott, Morse, and Lynch families have served in both organizations. (Courtesy of the Canton Historical Society.)

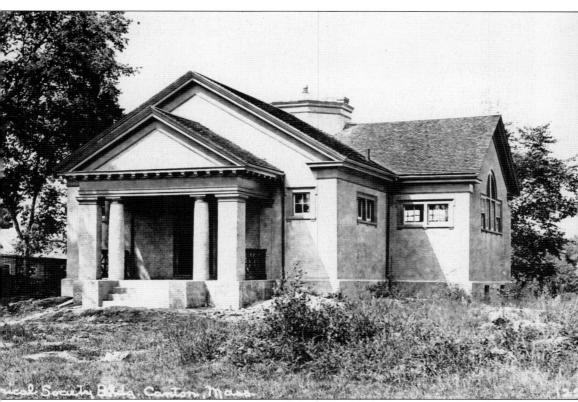

Founded in 1871 and incorporated in 1893, the Canton Historical Society is affectionately known as the "Histy." Daniel T. V. Huntoon was the first society president, and under his guidance, the group began researching and preserving local history. Early meetings were held at the Unitarian Hall. In 1909, George F. Sumner deeded a small mill and land to be used for the society. This 1911 postcard shows the building construction nearing completion. An early appeal reads: "We want to treasure up all the old traditions from the time of the Indians to the present day. We should like, above all things, to rummage in forsaken attics, to ransack those moldering . . . We have reason to believe that bushels of this old stuff are yearly given to the flames, and we desire to save it, and that immediately; for if we of the present generation allow these precious memorials of the past to be lost, no industry, no wealth can supply the deficiency." (Courtesy of Charles S. Crespi.)

The society has material that represents Canton, New England, and the United States. There are wonderful artifacts from the founding of Dorchester, Stoughton, Ponkapoag, and Canton. Items from the Revolutionary War, Civil War, both world wars, and all subsequent conflicts are in the catalog. Items representing local industry and inventors make this a superb source for information. This is a postcard photograph taken in 1922 by L. H. Benton of Taunton. (Courtesy of the Canton Historical Society.)

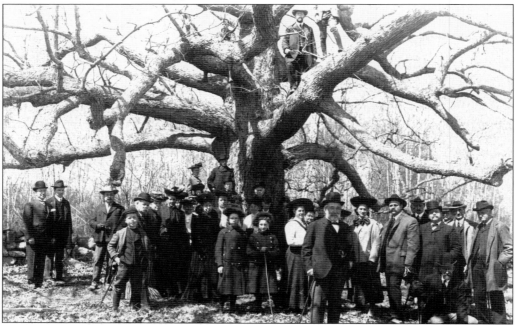

The first Fast Day was declared in Boston on September 8, 1670. Here the Canton Historical Society is out on a (secular) Fast Day walk on April 19, 1905. Fast Day walks were an annual historical event in Canton. Fast Day was abolished by Massachusetts in 1894, being replaced with Patriots' Day. The society continued to have Fast Day walks long after the day ceased to be a public holiday. (Courtesy of the Canton Historical Society.)

Five

Just Passing Through

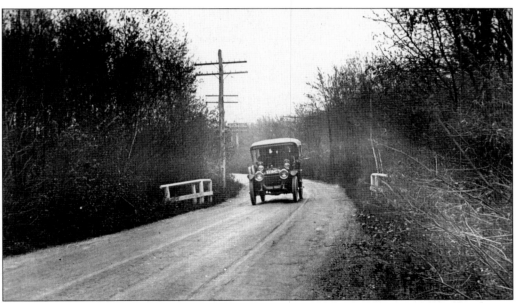

Turnpike Street was laid out as a toll road in 1806 as part of the Stoughton Turnpike Corporation. This toll road offered a through route from Taunton to Roxbury. The corporation was dissolved in 1839, and the road was laid out as a county highway in 1840, except for a portion in Stoughton, which was laid out in 1856. An early glass plate shows Turnpike Street, Route 138, as it passes through Canton. (Courtesy of the Canton Historical Society.)

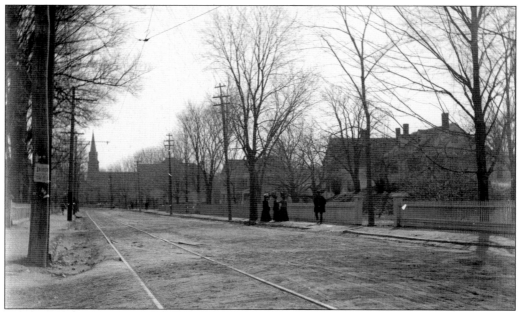

An 1897 view of Washington Street finds a dirt road winding through Canton that begins at the foot of the Blue Hill and extends through South Canton, where it joins Bay Road. This is the King's Highway and Canton's most ancient way. Portions of this road existed in the middle of the 17th century. This photograph was taken at Sherman and Washington Streets looking toward what would become downtown Canton. In 1883, Canton had three livery stables to support the transportation needs of the growing community. Even as late as 1912, the town rented horses to support the fire department at a sum of $741. The photograph below shows the fireman's parade on Neponset Street. (Above, courtesy of the Canton Public Library, Daniel Keleher Collection.)

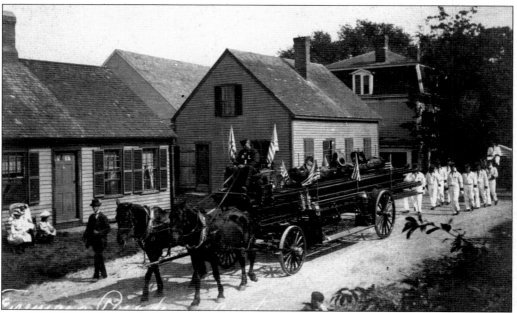

It was not all business along the central part of Washington Street. Many elegant homes graced this road. One of Canton's most influential statesmen was the Honorable Ellis Ames. Ames was born in Stoughton in 1809 and died in Canton 1884. Ames attended college at Bridgewater Academy, and in 1830, he graduated from Brown University. An expert in Colonial history, in 1832 he successfully argued a case in the U.S. Supreme Court that decided a boundary dispute between Massachusetts and Rhode Island. His house (below) was located at the corner of Washington and Church Streets and was built around 1840. In his home, he had one of the finest law libraries in the commonwealth. After he died, a postcard featuring the portrait of a young Ames was circulated, perhaps as he graduated from Brown University. (Courtesy of the Canton Historical Society.)

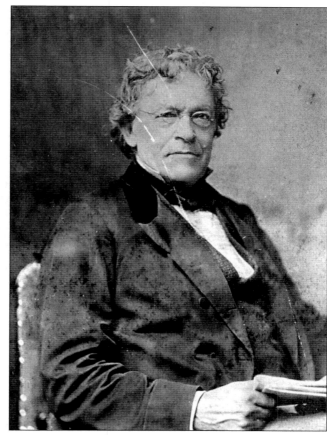

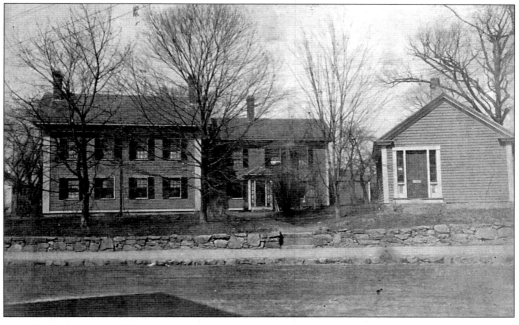

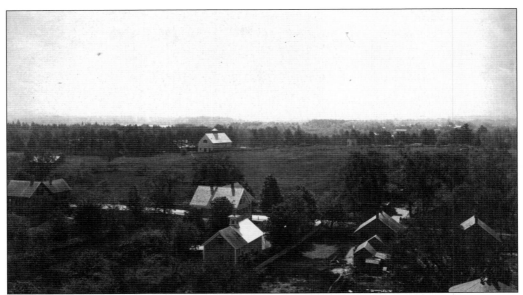

This photograph, taken in 1899 by Chester Horton, shows rural Canton at the beginning of the 20th century. Washington Street is the road that crosses at the middle of the photograph. The barn in the distance is the Draper barn at Pequitside Farm. The Draper family owned many of these homes, and this photograph was taken high atop one of the chimney towers of the Draper mill complex. (Courtesy of the Canton Historical Society.)

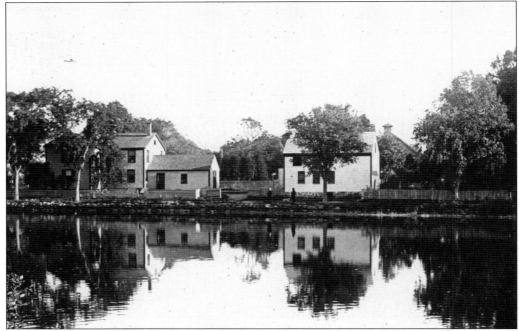

This early view of Shepard's Pond casts a reflection on another rural portion of Washington Street in the late 1800s. An iron forge was built here and used by Nathaniel Leonard. Leonard was born in Stoughton in 1744 and died in 1799. Leonard's first wife was Mary Shepard, and the family names are among the earliest in Canton's records. (Courtesy of the Canton Historical Society.)

This view was taken at the falls on Washington Street. Leonard erected the first milestone ever placed in the town. The inscription reads "B.17, M 1736. N. L.," and it was carved by Leonard. The Leonard family is buried across the street in a small private cemetery that is lost to most memories. The forgotten cemetery contains the graves of the Gridley, Billings, and Leonard families. (Courtesy of the Canton Historical Society.)

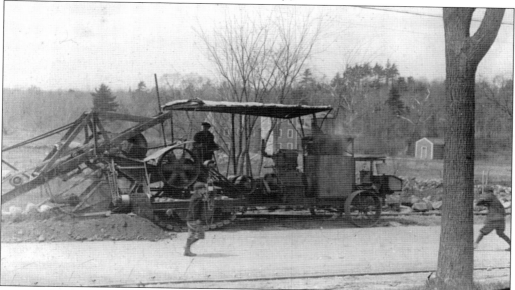

Digging of another sort is shown here along Washington Street, just south of Dunbar Street. This is a 1906 view of a trenching operation. A mill for making cotton twine has been at this site since 1821. In the background is the G. H. Mansfield Fishing Line Company, manufacturer of the finest silk fishing lines in the world. Mansfield also made twine, violin strings, and drum snares. (Courtesy of the Canton Historical Society.)

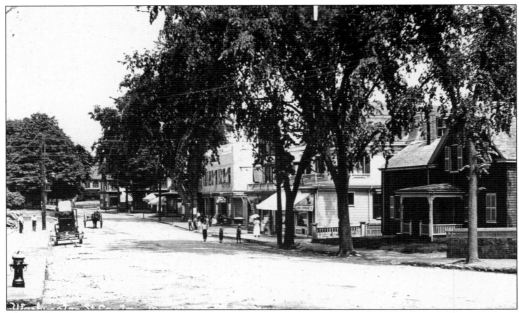

A typical day is portrayed in this postcard that was postmarked in 1912. On the right are several buildings, a few of which are still located between Neponset and Rockland Streets. There is a large group of children lined up to get ice cream at Boda Lunch, and Curry's shoe store is doing a brisk business. The first large building is the Brown Hotel, built in 1865, and the barbershop on the corner is the Barton Store built around 1852. (Courtesy of Peter Sarra.)

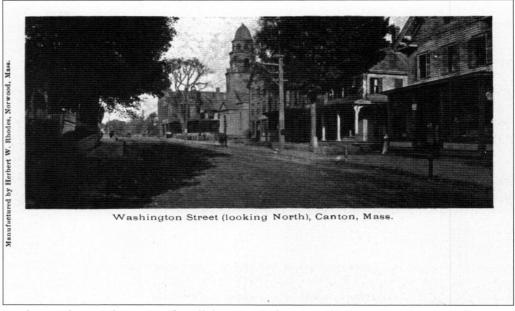

Washington Street (looking North), Canton, Mass.

Further south is another series of small shops just before the old Universalist church on the corner of Washington and Mechanic Streets, now the location of the Canton Market convenience store. Washington Street was lined with beautiful elm trees that were destroyed by the Dutch elm disease that arrived in 1928. (Courtesy of the Canton Public Library, Daniel Keleher Collection.)

Known as Amos Holmes' Store (above) as well as Fuller Brothers, this building stood at the corner of Washington and Neponset Streets. The large stone building was constructed in 1836 and served as school No. 3, Ingraham's Branch, until the Gridley School was built in 1854. The second floor was once home to the Italian American Club and in 1922 the Wauk-Ezy Company, cofounded by Frank Webster and Dr. O. P. Wolfe of Norwood. Their company produced very popular high-grade moccasins. Below is a postcard of the well-known Amos Holmes and perhaps Margaret Lynch Brady. The building was demolished in July 1969. (Courtesy of the Canton Historical Society.)

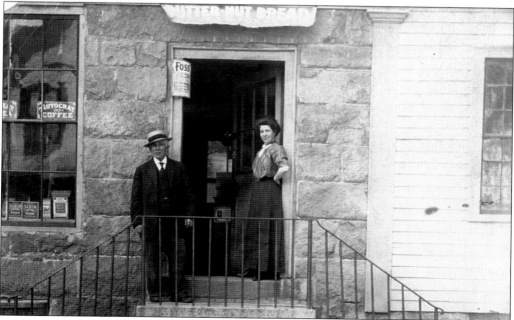

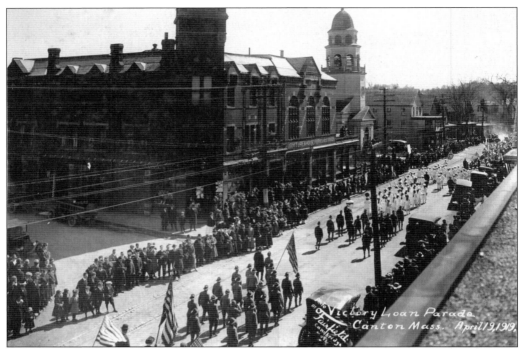

Washington Street was the site for so many parades and festivals, much as it continues today. Many impressive buildings lined the sidewalks at the corner of Bolivar and Washington Streets. These photographs show the 1919 Victory Loan Parade as it marches up Washington Street past Brooks Block and the old Universalist church. Hundreds of residents lined the route to watch the parade that celebrated the successful completion of the Victory Loan Campaign, which issued bonds to finance the expenses of World War I. A great curiosity was the Whippet tank (below), which had dozens of boys in tow and made a special stop at the end of the parade to allow for a closer view. (Above, courtesy of the Canton Historical Society; below, courtesy of the Canton Public Library, Daniel Keleher Collection.)

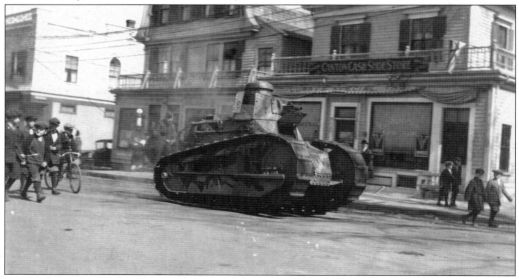

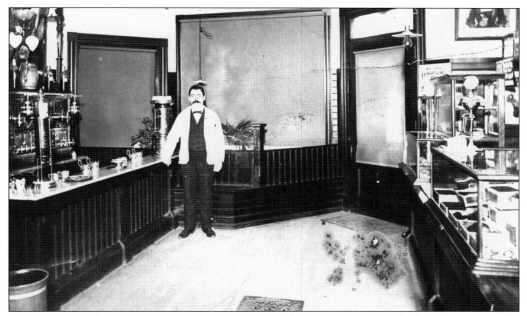

Ice cream was the feature attraction at Briggs Brothers. The classic soda fountain and lunch counter was located in Pitcher's Block, at the corners of Rockland and Washington Streets. Briggs Brothers advertised as having a plant "that is turning out the finest smooth and velvety Ice Cream that is made. Put up in slices in brick form or bulk." (Courtesy of the Canton Public Library, Daniel Keleher Collection.)

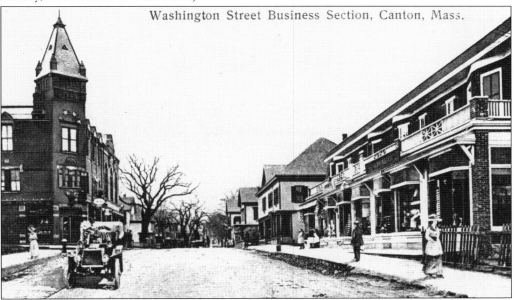

This postcard was published in 1912 looking up Washington Street toward Bolivar Street. On the right is the Plymouth Block, built just before 1911. Built for Abraham Sydeman, a wealthy businessman and the treasurer of Plymouth Rubber Company, the building housed retail stores, hardware, grocery, and dry goods stores. The photograph on page 78 was taken from the flat roof of this building. (Courtesy of the Canton Public Library, Daniel Keleher Collection.)

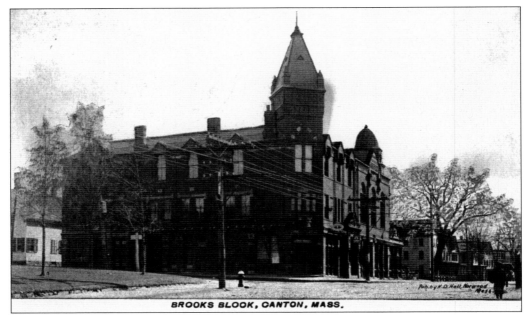

BROOKS BLOCK, CANTON, MASS.

At Bolivar and Washington Streets stood Brooks Block. This 1910 view is captivating. Quite literally, this building was a showstopper of wonderful proportions. Most of the postcards that feature the downtown take this building into the view. This was a significant block and was the home at various times to the post office, telephone exchange, and its namesake William W. Brooks pharmacy. The structure burned in a magnificent fire in 1943. (Courtesy of Charles S. Crespi.)

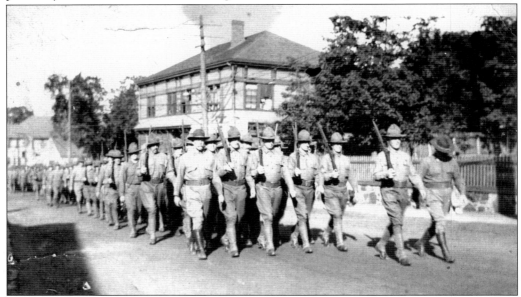

Many parades marched Washington Street, and here is the Canton Home Guard in a postcard dated between 1907 and 1914. The Canton Home Guard was quartered in the Memorial Hall basement. Leading the troops are Ben Morse, Winthrop Packard, and Bill Revere. The building is Tucker's Block, and it was located just between the waterfall and parking lot in the center of town. (Courtesy of the Canton Public Library, Daniel Keleher Collection.)

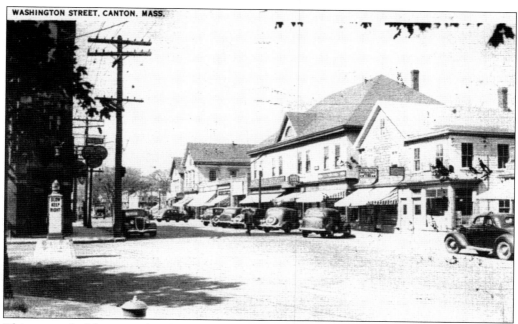

This postcard of the center is a time capsule in so many ways. It is wonderful to see angled parking and the Flood Block in the background. Built by Michael Flood in 1900, this large building once housed a tailor, the post office, fruit shop, and an early home for the Canton Institution for Savings (Bank of Canton). What is truly wonderful is the back (below) of this postcard and the postmarked date of September 23, 1938—two days after the great Hurricane of 1938. The Blue Hill Observatory at its 635-foot elevation recorded a gust of wind out of the south at 186 miles per hour with a sustained wind of 121 miles per hour between 6:11 and 6:16 p.m. Only one anemometer survived these winds, which still remain the second highest winds ever recorded on earth. (Courtesy of Peter Sarra.)

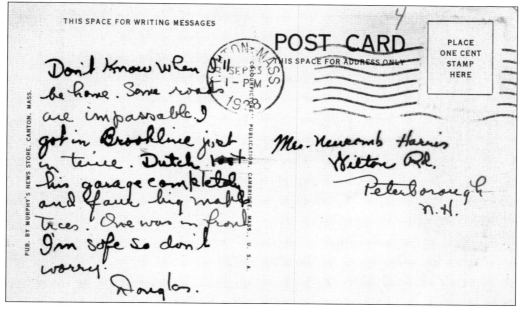

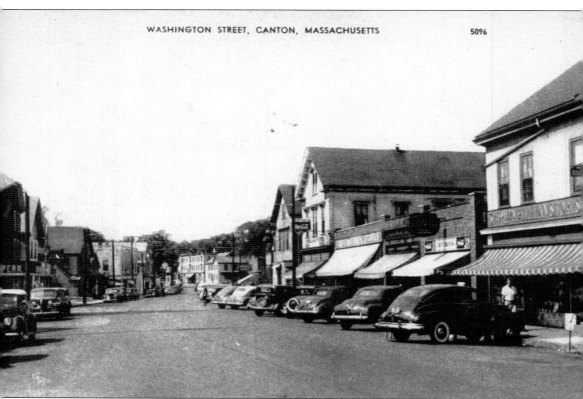

So many changes have occurred in downtown Canton. Most recent development has focused on revitalizing to include more picturesque streetscapes and pedestrian-friendly design. Parking has been radically managed over the years, and today's downtown boasts underground utilities, spacious benches, and pocket parks as well as historical markers. The view captured here shows the center in the heyday of the Nickel to Dollar Store, the First National Store, and Modern Cab Company. A closer look seems to reveal an early home for the Canton Town Club on the second floor of the building at the corner of Wall Street. The Coca-Cola signs, striped awnings, and a void of traffic are nostalgic images.

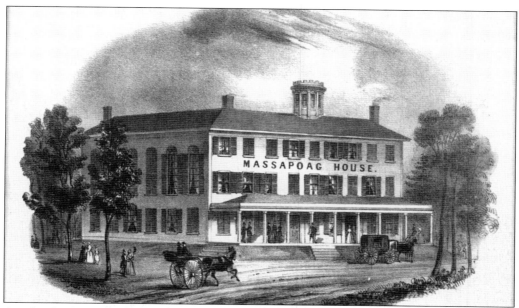

Another landmark in Canton Center was the Massapoag House. It was built in 1789 as a private residence for Jonathan "Quaker" Leonard. Leonard lost the house to his creditors, and the building became a public house. The Canton Lyceum (a literary society) met regularly at this tavern. By the time the viaduct was being built, James Bent was running his tavern and a stagecoach line from Canton to Boston. In 1848, Lyman Kinsley expanded, remodeled, and added a third story, thus creating the finest county hotel in New England. The drawing above was featured on the opening playbill for the grand ball held on February 3, 1848. In 1909, the Catholic Church bought the building at auction. The postcard below is a 1910 view as workers pour concrete for a new driveway. (Below, courtesy of the Canton Public Library, Daniel Keleher Collection.)

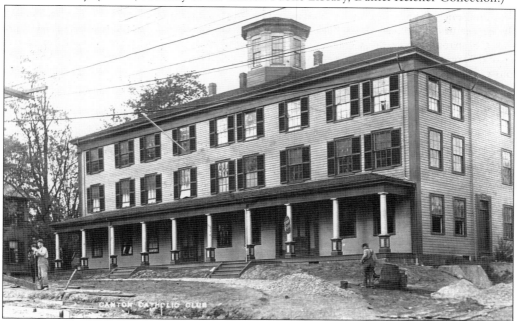

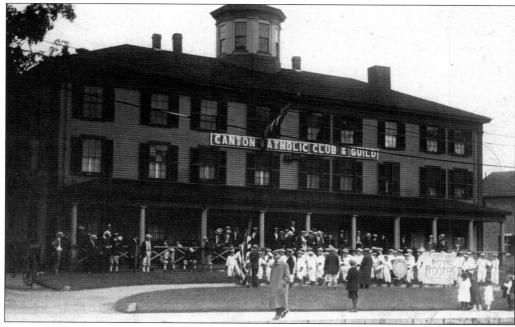

The association more closely recalled with this building is that of the Canton Catholic Club and Guild. The basement boasted three bowling alleys, while a movie theater showed silent films, and in the rear of the first floor there was a large billiards parlor. Canton's Catholic population had swelled during the late part of the 19th century, and to help occupy their attention and time, the Catholic Club offered many diversions. In these two postcards, a group of boys in amazingly white uniforms can be seen parading as the Canton Royal Rooters of 1915. On the porch, baseball players and men in straw hats watch over the scene. (Above, courtesy of the Canton Historical Society; below, courtesy of the Canton Public Library, Daniel Keleher Collection.)

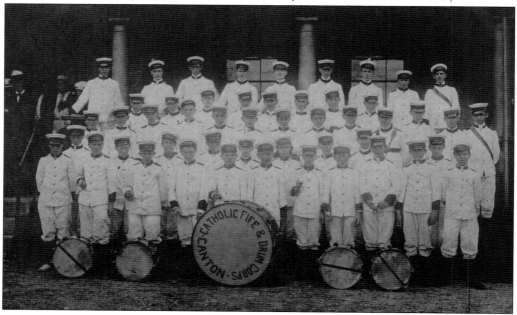

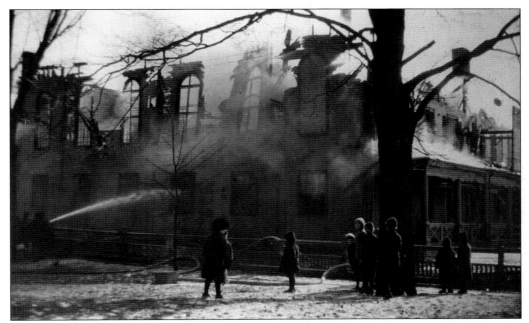

Early on January 5, 1918, fire destroyed the 130-year-old structure. "It was an absolutely fascinating thing to watch," recalled town clerk Carlton Taber, who as a young boy remembered being at the scene after hearing the fire alarm split the frigid morning air. "The water became ice in nothing flat." Judge Gregory Grover took this photograph from his front lawn where the fire was fought. (Courtesy of the Canton Historical Society.)

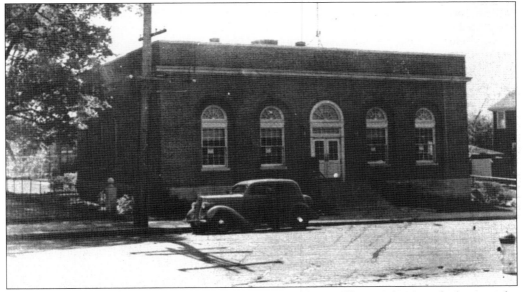

In 1936, the U.S. government built a simple brick box post office on the site of what was the Massapoag House. The architect was Louis A. Simon and Klayman Construction Company built the building. Most notably, the interior lobby features a Depression-era mural done by Ernest Fiene and features Paul Revere and sons and the 1801 rolling mill in Canton. (Courtesy of the Canton Public Library, Daniel Keleher Collection.)

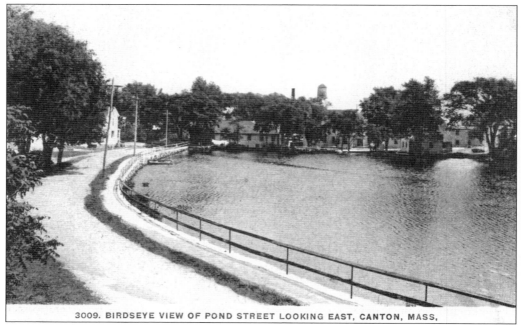

3009. BIRDSEYE VIEW OF POND STREET LOOKING EAST, CANTON, MASS,

There are still streets and views that have largely been unchanged over the past 100 years. Many of these areas are just off Washington Street, and in some cases, the proximity to wetlands have allowed for limited development, which in turn, has preserved the history of the surrounding homes. One such example is Pond Street, and a drive today looks much like it did in this postcard from the early 1920s. (Courtesy of Charles S. Crespi.)

The Bolivar Boat Club, located on Mechanic Street, provided waterfront access and entertainment for veterans from the Civil War and both world wars. Not everyone performed a perfect dive; however, in 1908 Harold Olson, dove against a rock and severely cut his head. Dr. Dean S. Luce was called and sewed up the wound. The *Canton Journal* reported, "Harold is the son of Emil Olson. He is expected to recover." He did. (Courtesy of Charles S. Crespi.)

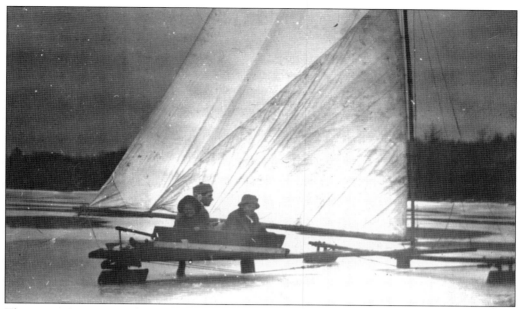

The reservoir is among the most picturesque spots in the area. Situated in the geographic center of town, it encompasses almost 300 acres of land. This man-made pond was created in 1827 on property that was sold to the Neponset Woolen Company for $314 and subsequently became owned by the Revere Copper Company. In this rare glass slide, three daredevils are seen out on an ice sailing adventure. (Courtesy of the Canton Historical Society.)

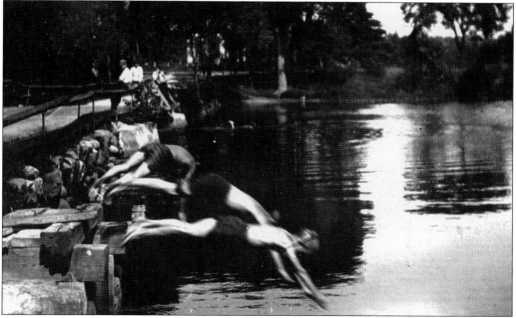

Canton was an active vacation spot, and the abundance of lakes and streams brought anglers and weekend boaters. Clear water fed by streams crisscross the town, and in many cases, land is never far from a brook or wetland. This early glass slide shows boys diving from the dam on Reservoir Pond. (Courtesy of the Canton Historical Society.)

Between 1905 and 1911, the popularity of postcards grew into a craze as they were produced and sold in record amounts. During this time, collectors purchased many postcards, and postcard clubs were popular. As people would pass through Canton, they would frequently stop in the local drugstores and pick up a souvenir of their visit. The postcard was an inexpensive treat to buy and perhaps send to loved ones promoting their trip. This card is undated and never sent, kept as a collectable. (Courtesy of the Canton Public Library, Daniel Keleher Collection.)

Six

THE PATH
BETWEEN HOUSES

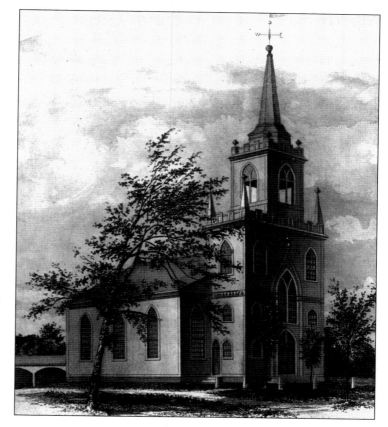

A landmark house, the First Parish Unitarian Universalist Church has graced Canton Corner since 1824. This engraving shows the church in all its glory as the church committee envisioned it. Built by Capt. William McKendry, this Gothic Revival church is among the earliest of its form still surviving in Massachusetts. (Courtesy of the Canton Historical Society.)

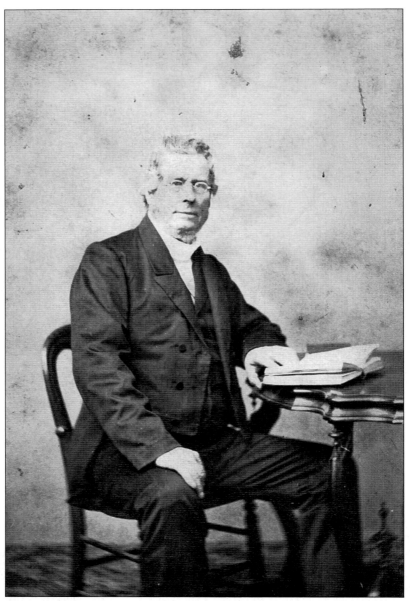

The Reverend Benjamin Huntoon was one of Canton's foremost citizens. Born in Salisbury, New Hampshire, in 1792, he graduated from Dartmouth in 1817 and soon thereafter entered the seminary at Andover. In his early associations with Canton, he would travel by horse from Boston and stay in Ponkapoag and preach to his flock. By 1822, he was ordained and began a lifelong association with both his calling and his adopted hometown. So powerful were his sermons that a contemporary remarked, "be careful or he will steal away all your hearts." In December 1823, a parish meeting laid the groundwork for a new church to be constructed. And throughout the next five decades, Reverend Huntoon would pursue religious missions both in Canton and in other locations. Huntoon was a passionate gardener who spent many years planting trees and beautifying the cemetery. Huntoon died in Canton in 1864 and is buried at Canton Corner Cemetery. (Courtesy of Peter Sarra.)

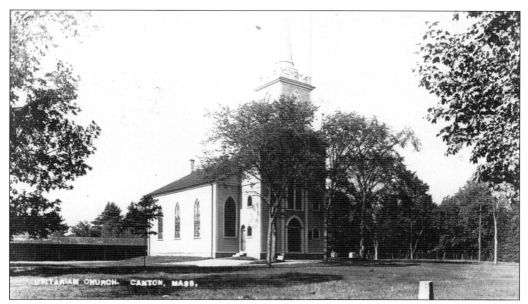

In 1824, the committee that was charged to build the church visited Chelsea and ultimately found as their source of inspiration Asher Benjamin's Old West Church in Boston. The shape and format of the church is based on Benjamin's, but in Canton, the Gothic architecture was an architectural invention ahead of its time. When it was built in 1824–1825, it was known as the Congregational Parish and Society of Canton. (Courtesy of Charles S. Crespi.)

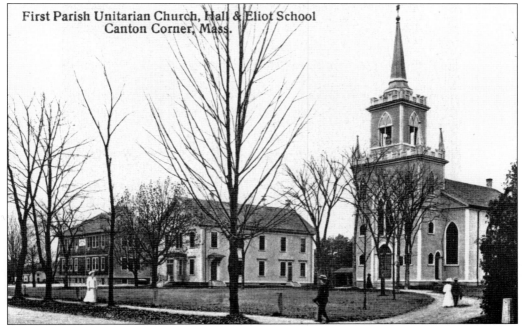

This postcard dates to 1912 and shows the church, the parish hall, and the Eliot School with expansive front lawns in the area known as Canton Corner. The view is hardly any different today. In 2009, the Massachusetts Historical Commission voted that this area become a national historic district. (Courtesy of the Canton Public Library, Daniel Keleher Collection.)

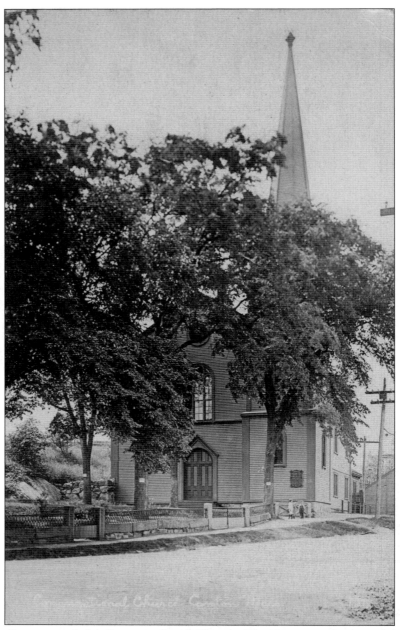

In Canton Center stood the Congregational Church. The site was quite near the apartment buildings as one comes down the hill from Neponset Street onto Washington Street. Hidden by the trees in this 1915 postcard is the wooden church viewed as one looks from Washington Street at Neponset Street. Dedicated in 1860, the total cost was $6,895. It was built by John Ellis Seavey, whose family has long and memorable connections to Canton. In 1961, the church was renamed the United Church of Christ. After 103 years, the church was replaced, largely because the congregation had outgrown the church and families needed more space for programs and fellowship. By 1963, a new church was opened near St. Mary's Cemetery on Washington Street, and the congregation moved to its new home. (Courtesy of Charles S. Crespi.)

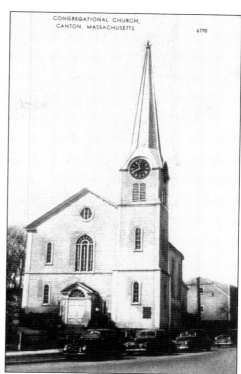

CONGREGATIONAL CHURCH,
CANTON, MASSACHUSETTS
6770

Another view (seen at right), in late 1940s, showcases the beautiful steeple that had an E. Howard clock manufactured in Roxbury. The clock and one face are now in the dormer at Memorial Hall, with the remaining sides at the Canton Historical Society. The interiors, pews, and pulpit, along with the top of the steeple, were all constructed by one man, Hugh MacPherson. While simply visiting the town, MacPherson saw the first loads of lumber arrive and decided to help build the church. A devout Baptist, MacPherson nevertheless assisted and soon became a deacon of the church he helped to build. The photograph below was taken in April 1969 by Roy Gorton. The church property was sold to the Mobil Oil Corporation in 1969 for $50,000 and was demolished. (Courtesy of the Canton Public Library, Daniel Keleher Collection.)

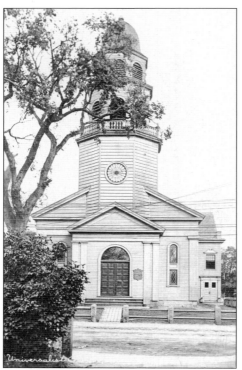

Another lost artifact from Canton Center's past is the Universalist church. Universalism spread through the doctrine of John Murray, who visited Canton twice while officiating at the funerals of Richard and Hannah Gridley. Gridley, a Revolutionary War hero, was shunned because of his religious views, to which he answered, "I love my country, and my neighbor as myself. If they have any better religion, I should like to know what it is." (Courtesy of the Canton Public Library, Daniel Keleher Collection.)

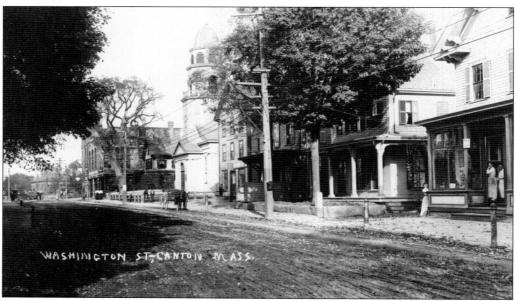

By 1849, when this church was built, there were 33 families in the congregation. The early incorporators of the church where a veritable who's who of Canton families including Billings, Shepard, Messinger, Fowler, Mansfield, Chandler, Holmes, Deane, Wentworth, Seavey, Endicott, Munson, Lincoln, and Poole. This early-20th-century postcard view of Canton Center shows the prominence of the church. (Courtesy of the Canton Public Library, Daniel Keleher Collection.)

This is an early photograph of the Universalist church on Washington Street. As the years passed, many common beliefs between Universalism and Unitarianism were recognized. As early as the 1850s in fact, there was a move to unite the beliefs of the two religions. It would take more than 120 years to finally decide the issue. (Courtesy of the Canton Public Library, Daniel Keleher Collection.)

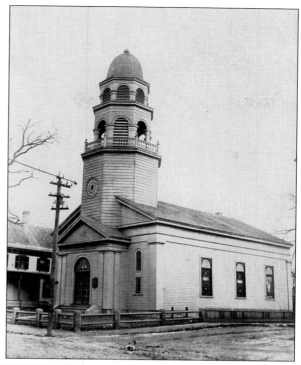

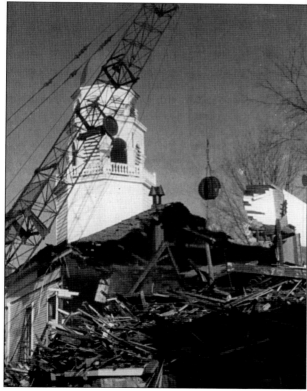

In 1974, the Canton Universalist Church and the Canton Unitarian Church merged and became the First Parish Unitarian Universalist. On a weekend in November 1977, the 130-year-old church was demolished. The bell from the steeple is now located on the lawn of the church at Canton Corner along with the cornerstone. (Courtesy of the Canton Public Library, Daniel Keleher Collection.)

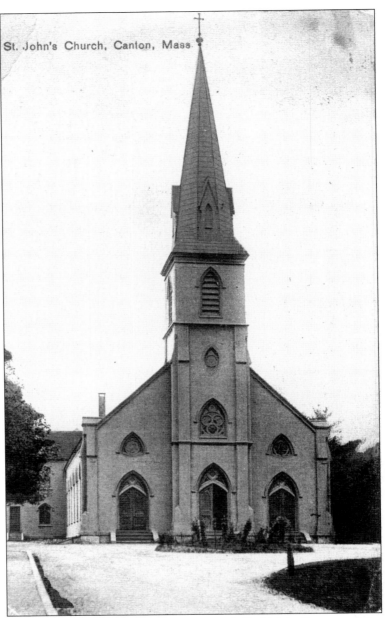

St. John's Church, Canton, Mass.

There are strong and early connections between the Catholic faith in Canton and the construction of the viaduct and the Revere family. Daniel Huntoon's history of Canton observes that in 1814, the Catholics certified by John Cheverus were Patrick Lambert, Gregory Doyle, James Kavanagh, Peter Ledwith, and Thomas Riley, and Huntoon opined "probably the first Irishmen in Canton." Likely drawn by construction projects at Neponset Woolen Mills and other stone buildings, the early Irish laborers were instrumental in the development of the factories and the railroad of the early 1800s. The Revere family, of French Huguenot descent, were sympathetic to early Catholics and may have been of some quiet influence in helping Irish laborers find work in Canton. Built in 1868, this postcard view shows the church on Washington Street. (Courtesy of the Canton Public Library, Daniel Keleher Collection.)

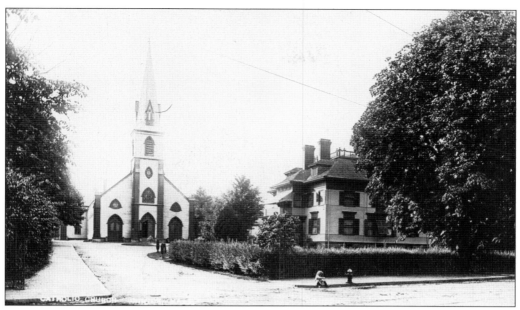

Looking closely as this postcard, a little girl sits on the curb along Washington Street just outside the property of St. John Church. Prior to constructing this wooden church, the Catholic congregation met in a small building at 25 Chapel Street. The congregation swelled as a result of the influx of immigrants that worked at Revere and Sons as well as other local factories. (Courtesy of the Canton Public Library, Daniel Keleher Collection.)

Built in 1889, the rectory of St. John's Church was constructed under the direction of Rev. Joshua P. Bodfish. A fine example of Colonial Revival design, it is likely that this building was built for Bodfish's silver jubilee at a cost of $18,000. It is the oldest building on the property and replaced the original "priest's dwelling," which was the Billings house. (Courtesy of the Canton Historical Society.)

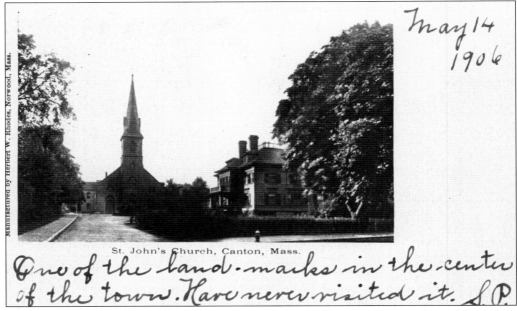

Manufactured by Herbert W. Rhodes, Norwood, Mass.

St. John's Church, Canton, Mass.

May 14 1906

One of the land-marks in the center of the town. Have never visited it. S.P.

The Catholic influence grew in Canton as more Irish and Italian immigrants migrated from their native countries and joined earlier generations at the mills, tanneries, and forges. Even before the church was built, St. Mary's Cemetery was laid out. Around 1850, the first burials took place. By 1861, there were over 1,300 worshippers, necessitating the construction of a church. The property in Canton Center also housed the St. John's Convent built for the Sisters of St. Joseph in the 1920s and designed by Matthew Sullivan. The original school was built in 1883 and opened with 800 students. The reach was far and wide and many postcards were published to highlight the various properties under St. John's influence. (Above, courtesy of the Canton Public Library, Daniel Keleher Collection; below, courtesy of Charles S. Crespi.)

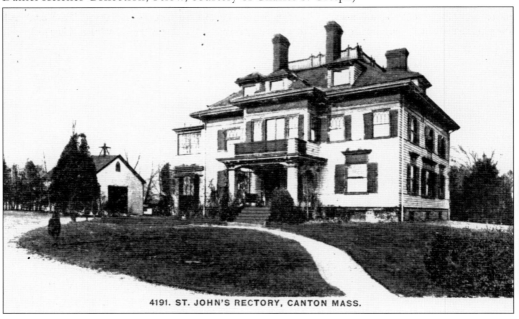

4191. ST. JOHN'S RECTORY, CANTON MASS.

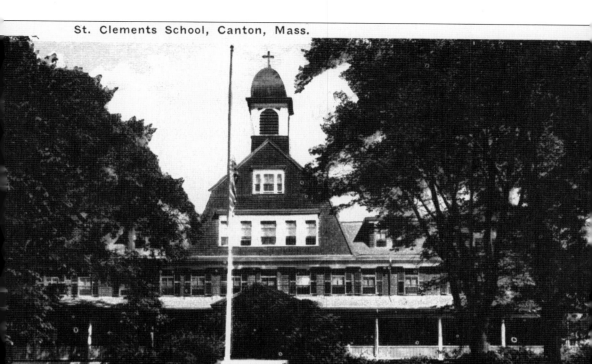

16865

St. Clement's School for Boys was located behind the present-day St. John's school and managed by the Sisters of St. Joseph. This preparatory school was run from 1922 through 1950. This building was a boarding school for boys, and in the summer, the nuns would manage a girl's boarding camp. In 1938, there were 25 boys registered and 10 faculty members. This undated linen postcard shows the beautiful building and grounds. (Courtesy of Charles S. Crespi.)

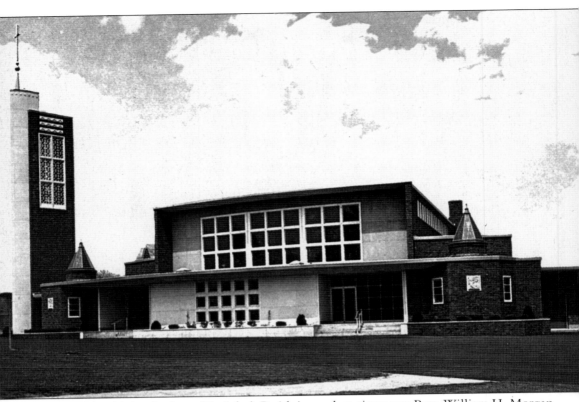

One of the shining leaders of St. John's Parish in modern times was Rev. William H. Morgan. Under Father Morgan's leadership, the parish began a program of growth and building. In 1956, the parish broke ground for a new elementary school that doubled the size of the previous building. In 1959, Richard James Cardinal Cushing dedicated a new parish center. The convent was enlarged after extensive renovations in 1960. Finally, in 1963, the traditional wooden church was demolished to make way for a modern brick church that is bright and thoroughly contemporary. This postcard view shows the new St. John's on Washington Street. Designed by Whelan and Westman of Boston, the building was designed in the shape of a bell to accommodate 1,000 worshipers. Harvey Salvin of Malden created the stained glass that is an integral element of the church. (Courtesy of Peter Sarra.)

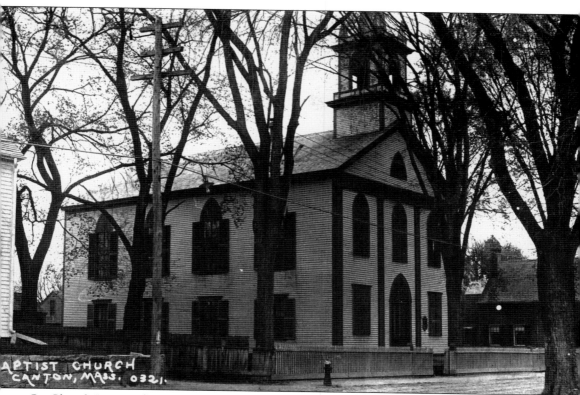

APTIST CHURCH
CANTON, MASS. 0321.

On Church Street is the Masonic hall. This building was originally the Baptist church. In 1811, plans were made to establish the Baptist church. William Ritchie, the minister of the First Parish, was extremely agitated and denounced the followers as "creatures of the night" and an "ungodly community." Early baptisms were performed in Reservoir Pond adjacent to the present site of the Wampatuck Country Club. The first converts included Ezra Tilden and many other prominent Canton names. Family names that belonged included Tucker, Capen, Gill, Crane, Fuller, Withington, Crowd, and McKendry. The first church was built in 1818 on land near the present-day historical society. The church shown in this postcard was built in 1837 for a cost of $3,300. In 1839, a bell from the Revere Copper Company was purchased for $250 and was hung in the belfry. In 1932, the Baptist congregation united in worship with the Congregational Church, and in 1940, the building was sold to the Blue Hills Lodge of Masons as its temple. (Courtesy of the Canton Historical Society.)

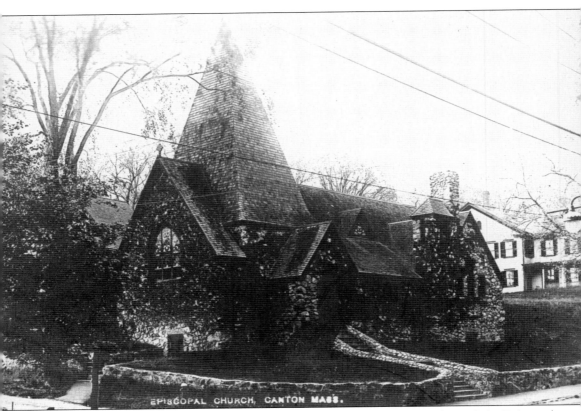

EPISCOPAL CHURCH, CANTON MASS.

Another building that began life as a church but now has another use is the first Trinity Episcopal Church on Washington Street. In 1897, the small Episcopal parish built its new home, modeled in the English tradition. In 1906, the church came into possession of an unusual bell donated by Edward H. R. Revere. The bell was cast in Cincinnati in 1856 for a church in New Orleans. It was confiscated by soldiers of the Union army and was brought north to be melted for cannon by the Revere Copper Company. Its clear tone saved it, and it was hung in the Revere Copper Yard. When the Revere mill closed, the family donated it to Trinity Episcopal Church. The new church cost about $5,000. In 1964, Martha Prowse donated five acres of land at the foot of Blue Hill. A new church was erected in 1969. The bell was hung in a new freestanding bell tower. The chapel was sold to Schlossberg-Solomon as a funeral chapel. The Schlossberg family restored the chapel, and its use continues today. (Courtesy of the Canton Public Library, Daniel Keleher Collection.)

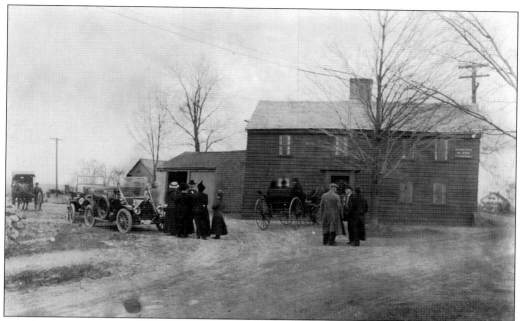

The Fenno house was one of Canton's original historic sites. Built by John Fenno, for many years this was the oldest house in Canton. The *Canton Journal* wrote in a history column, "It stands out boldly in the highway as if to demand notice, and the traveler is forced to go almost around it as he journeys to Randolph over the old road to Bear Swamp. It has an ancient look; its roof is moss grown, and wide clapboards and narrow windows mark it as a relic of the days departed." The land on which it stood was granted from the town of Dorchester in 1657 to Roger Clap. It consisted of 500 acres beyond the Blue Hill. In 1694, it was sold to John Fenno of Milton for £100. (Above, courtesy of the Canton Historical Society; below, courtesy of Charles S. Crespi.)

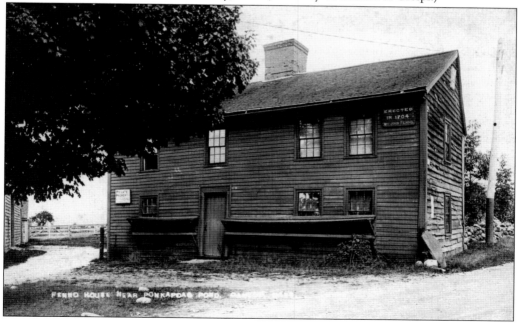

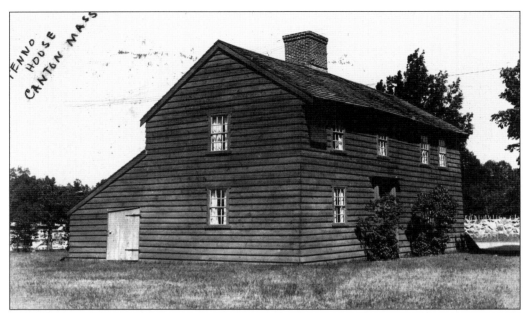

The Fenno house, believed to have been built in 1704, is one of Canton's original historic sites and well known throughout the 19th and early 20th centuries. The back of the postcard above reads "photo I took, the old house is open Sunday's .25 admission proceeds for Red Cross." Ultimately the Fenno house was deeded to the Canton Historical Society, and in 1949, the society donated the house to the fledgling collection at Old Sturbridge Village. Below is a modern photograph of the Fenno house. Architectural historians at Sturbridge had long been suspicious of the reported construction date, and in 2006, they undertook research that involved dating the house using timbers and matching known tree ring patterns in New England. The analysis places the Fenno house construction date closer to 1724. (Above, courtesy of the Canton Historical Society.)

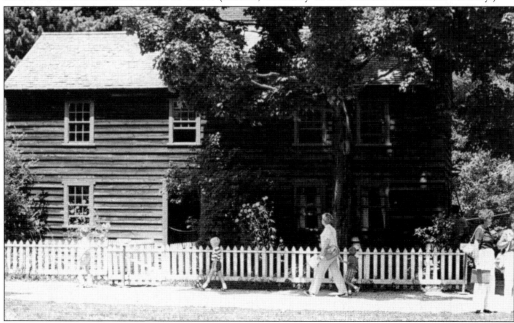

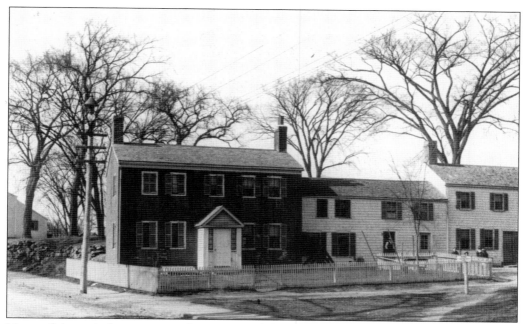

Many of the early houses are no longer part of the landscape in Canton. Here is a view from the 1890s of James Beaumont's block also known as British Block. It was once part of the Stone Factory District and located on Neponset Street near the viaduct. According to Daniel Huntoon, it was the second brick house built in Canton (in 1808) and perhaps the last brick building until Memorial Hall was built in 1879. (Courtesy of the Canton Historical Society.)

The Stone Factory District had many small rural homes and boardinghouses. The workers repairing the viaduct are shown here in a glass-plate photograph. Many of the men, women, and children that worked in the factories and along the railroad in Canton lived in this working-class neighborhood. (Courtesy of the Canton Historical Society.)

This is a postcard view of the James Endicott III house on Washington Street. The back reads, "My father, Frederic Endicott was born here April 12, 1839. His grandfather, James (the 3rd James) built it in 1807, when the original home built by the first James in 1720 burned down." James III served in the militia and was commissioned a lieutenant by John Hancock in 1790. This is the only surviving Federal-style home in Canton with a fully brick exterior. (Courtesy of Peter Sarra.)

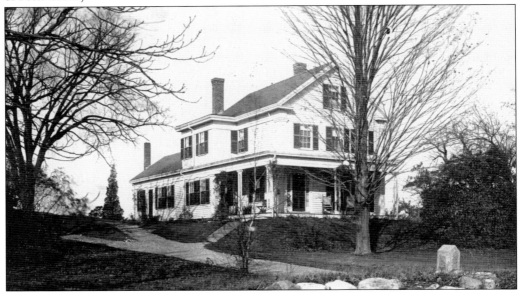

Just next door on Washington Street is another Endicott house, and one of the finest Greek Revival houses in Canton. This postcard view is of the John Endicott house that was built in 1852. The back reads, "Where I was born, Grandfather Endicott built in 1852, after grandmother Mathilda Endicott died father inherited this house. When father had a shock we moved from W. Roxbury here (1917) father died in 1918 . . . since their deaths I have lived here and live here now, 1950." (Courtesy of Peter Sarra.)

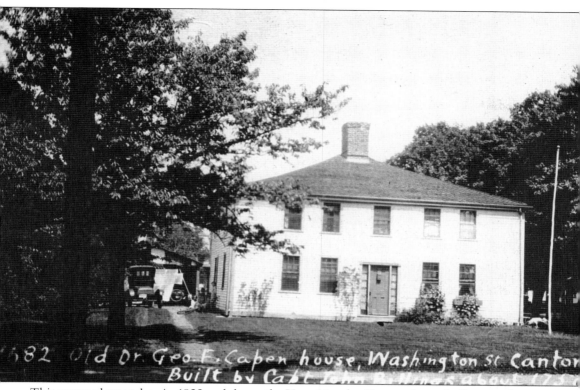

582 Old Dr. Geo. F. Capen house, Washington St. Canton
Built by Capt. John Billings about 175...

This postcard was taken in 1922 and shows the Vose-Moseley Tavern. It was built around 1740 for Ebenezer Moseley as a roadside tavern, on the site of an earlier tavern of John Vose. Originally located on Washington Street and Draper Lane, this ancient tavern was long appreciated as a landmark. With a low-hip roof and a prominent central chimney, it was an important Colonial building with large proportionate rooms. In the early 20th century, the Draper Company acquired the building and used it as a rental property. Listed as the resident in 1922 was Charles Roche, a mechanic; in 1939 Bruce Phelps, a shipper, and his wife; and Vivian Kenney, a typist. By the early 1990s, the tavern was dismantled amid sadness for the loss of history. The building was rediscovered in 2008 on Page Road in Lincoln by Arthur Krim. Krim had been asked to research the rumored reconstruction of the building by Wally Gibbs, the chairman of the Canton Historical Commission. (Courtesy of the Canton Historical Society.)

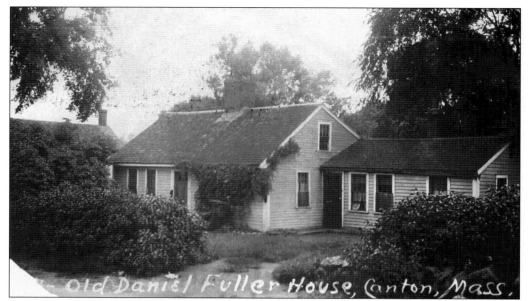

Old Daniel Fuller House, Canton, Mass.

There are still several mysteries to be solved when researching the photographs and postcards of Canton's history. And here are a few choice views within these pages, so the reader might help discover the history that accompanies these images. Above is a postcard view taken in 1922 that shows the Old Daniel Fuller house. Jim Roache, a native historian, believes that this house may have been on Neponset Street just past the Neponset Woolen Mills. The view below is that of the Billings house. A typical New England saltbox set on a large track of land, perhaps near Randolph Street. It is likely that both of these houses are now lost, but their history could still tell stories. (Courtesy of the Canton Historical Society.)

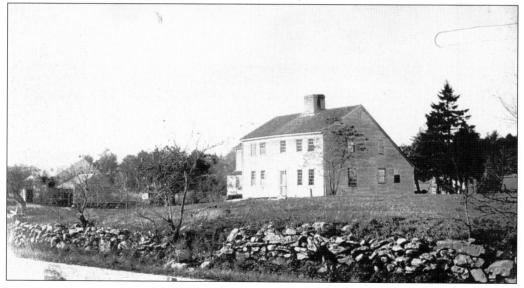

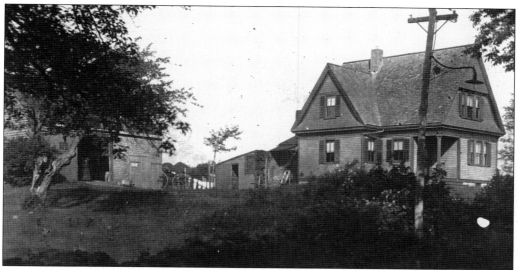

The photograph above shows a steep-peaked house on one of Canton's main streets and is only identified as "Cousin Ella's House." There is an electrical pole out front and a generous barn, and a lady stands in the door with a carriage in the yard. Few clues remain as to where this house was or if it has survived the years. And below is another mystery. This house was built in 1809 and is a classic Federal-style home. It is identified as the home of J. B. Porter, and the postcard was mailed in November 1911. It is thought the house was on Randolph Street in an area known as the Farms. Surely this house would be recognized today. (Below, courtesy of Charles S. Crespi.)

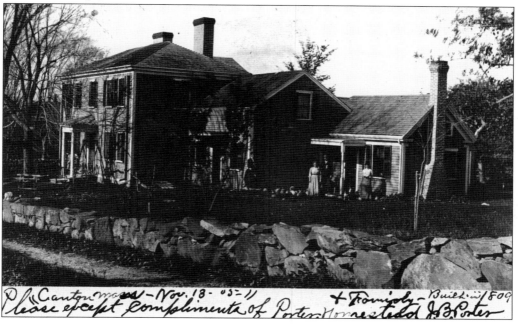

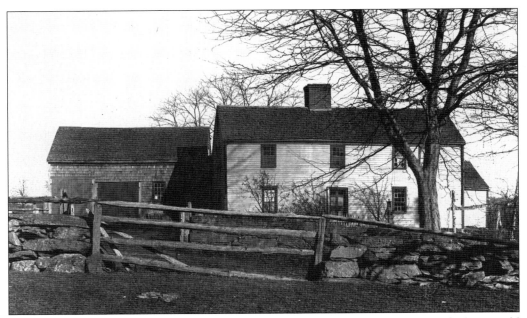

Two final puzzlers are presented here. The house above is a splendid example of what would have been a first period house in Canton. The setting is not unlike that of the Tilden House at Pequitside farm or Fenno house now at Old Sturbridge Village. From the style it would date to the early 1700s. This photograph shows the rural setting of the front yard with a water pump and classic New England stone wall. Finally, in the postcard below, a house is seen in 1914 that stands behind the stone pillars so frequently found in historic estate homes throughout town. This is a large house with dozens of windows and large chimneys servicing two wings. Many people find this home familiar, but the author does not know the identity. (Above, courtesy of the Canton Historical Society; below, courtesy of the Canton Public Library, Daniel Keleher Collection.)

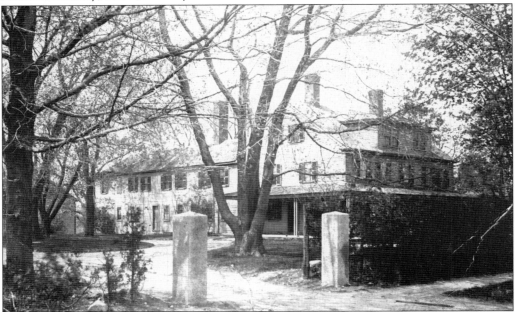

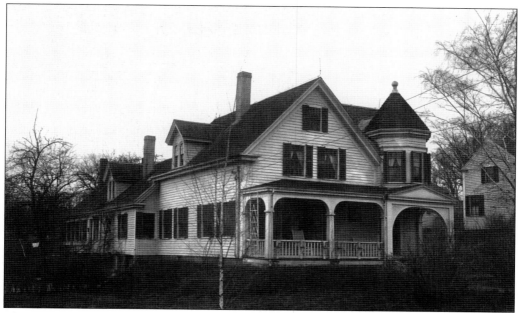

This is a postcard of the Deane house as it originally stood at the intersection of Washington and Sherman Streets, across from Memorial Hall. The house is still in Canton but was broken into two pieces and moved about a quarter of a mile from the original location. The front half, with the signature tower, is located on Sherman Street, and the rear portion is on Danforth Street. (Courtesy of Peter Sarra.)

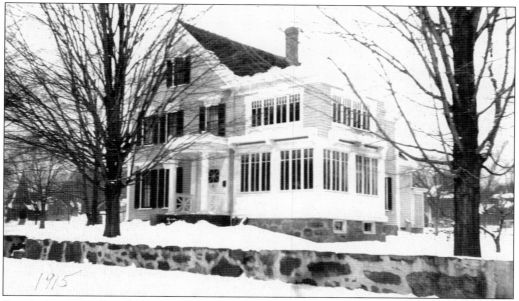

Another Endicott house, that of Charles Kingsbury "King" Endicott, is seen here as it appeared in 1915. King Endicott was one of Canton's most venerable public servants. Carrying on a long tradition of family service, he was appointed fire chief in 1925 and is credited with creating a first–class department of efficiency and strength. King also served as a state representative. The current owners have wonderfully preserved the house on Sherman Street. (Courtesy of Peter Sarra.)

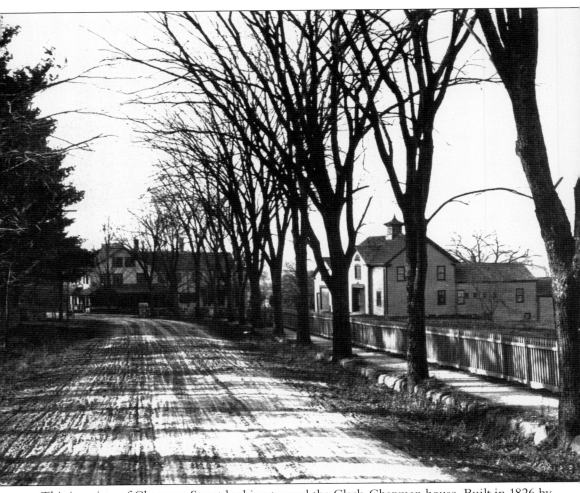

This is a view of Chapman Street looking toward the Clark-Chapman house. Built in 1826 by Marcus Clark to support his farm, it was extensively rebuilt in 1858 by Oliver S. Chapman. Chapman rented this house while working on the Canton Viaduct in 1834. Some 24 years later, Chapman bought the property. Chapman was an inventor and railroad engineer, and along with his cousin William Smith Otis, the two invented the American Steam Excavator—or as it is commonly known, the steam shovel. Chapman and Otis's invention was widely credited with building the equipment that expanded the American railroad and for the equipment that helped fill Back Bay in Boston. Longtime residents Betty and Larry Chelmow lovingly preserve this historic house. The image was taken very late in the 1800s and demonstrates the beauty of Chapman Street. (Courtesy of the Canton Historical Society.)

On the subject of inventors, perhaps the most important inventor that lived in Canton was James Amireaux Bazin. Born in Boston in 1798, Bazin was the son of a watchmaker, and in 1812 at the age of 14, his family moved to Ponkapoag. Bazin's obituary notice said "he was an ingenious lad, and early developed a taste for mathematics and the mechanical arts, the former which he pursued with avidity." (Courtesy of the Canton Historical Society.)

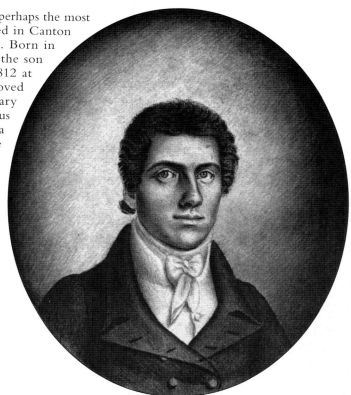

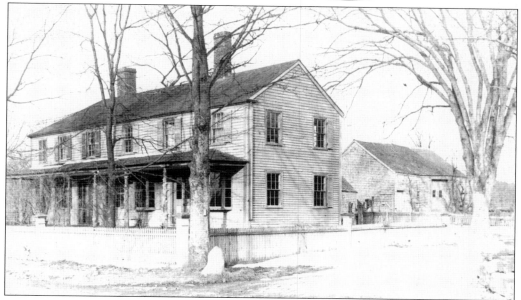

It was in this house, barn, and shed that Bazin tinkered and created his inventions. Credited as being the inventor of the first free-reed instruments in America, Bazin invented a vest-pocket pitch pipe and a reed trumpet, as well as a score of lap organs, a celestial model, a revolving trumpet, small cornets, and a transposing keyboard. (Courtesy of the Canton Historical Society.)

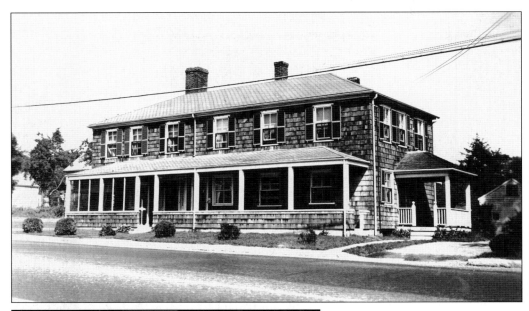

The house is still standing at the intersection of Route 138 and Washington Street next to the entrance of the Ponkapoag Golf Course. In the summer of 1831, James Bazin made a small instrument resembling the harmonica. The pipes were similar but were stationary. Arguably this was the first harmonica in the United States. Bazin was interested in the history of Canton and was always willing to share the information he had acquired during the 70 years he lived in Canton. From his father, he inherited his love of flowers, and his garden was well known. His house was a perfect museum, filled with antique furniture, rare old books, including the French Bible published in 1669. The Bible and many of Bazin's inventions are on display at the Canton Historical Society. (Above, courtesy of the Canton Public Library, Daniel Keleher Collection.)

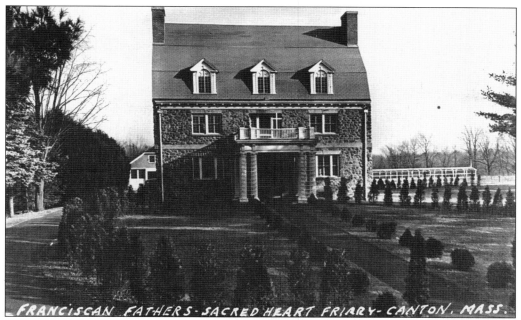

FRANCISCAN FATHERS-SACRED HEART FRIARY-CANTON, MASS.

This was the Sacred Heart Friary owned by the Franciscan Fathers and was located at 540 Pleasant Street. Polish Franciscan Fathers used this country estate as a retreat, and they tended to large gardens on the grounds. The building was acquired around 1938 and used for many years. The stately estate had a mansion that contained 15 rooms, 5 tile baths, a caretaker's cottage, extensive orchard and garden, a three-car garage, and eight acres of land. The property was listed in an advertisement for $14,000 in the early 1930s. In 1960, a portion of the land to the north was sold to the Columbian Associates and became the property of the Knights of Columbus where they erected the council headquarters. (Below, courtesy of the Canton Historical Society.)

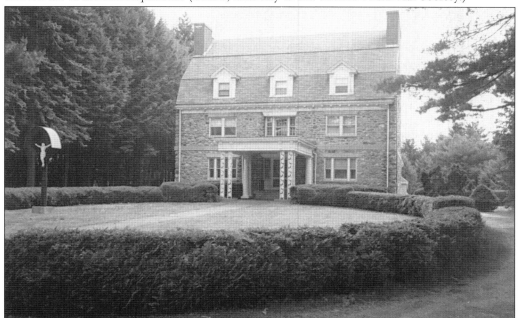

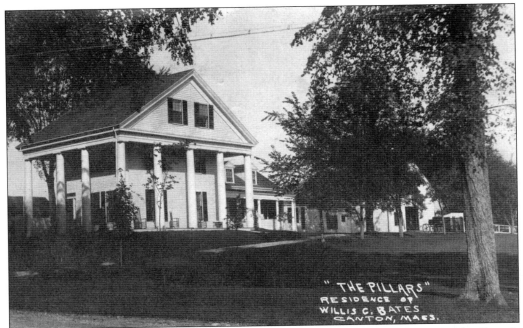

The Marcus Clark house is located on High Street and was constructed in 1851 by Francis Batcheldor of New York for Marcus Clark. The signature property has a series of two-story columns supporting the portico. In 1917, the house was converted to use as a hospital until Norwood Hospital opened in 1921. (Courtesy of Charles S. Crespi.)

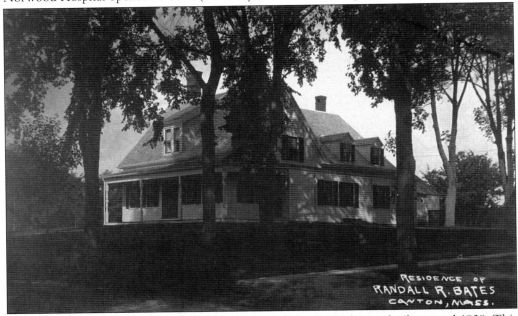

Just next door to the Marcus Clark house is the Joseph Leavitt house, built around 1839. This postcard shows the house in 1908 when Randall R. Bates lived there. By 1916, it was sold to Cordelia Litchfield, who rented it to the Canton Hospital as a nurse's residence. (Courtesy of Peter Sarra.)

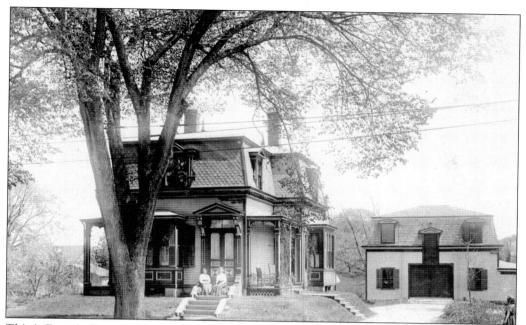

This is Bonnie Doon, a home built on Washington Street for Frank G. Webster. Built around 1870, Webster lived here through 1876. Webster was one of the founders of the Canton Public Library. Webster sought subscriptions for the library and was the first chairman of the trustees. In 1944, this home was converted to a funeral home for M. J. Dockray. (Courtesy of the Canton Historical Society.)

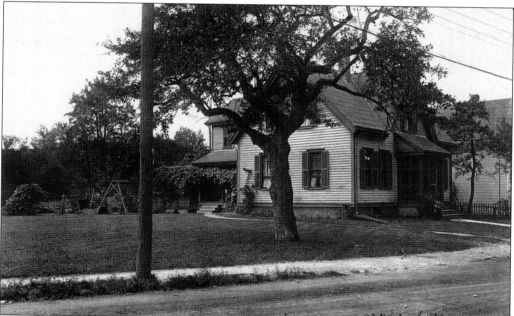

This private postcard shows the house at 45 Walnut Street near the corner of Messinger Street. The postcard dates to 1915, and the diminutive house is a charming home that still graces the tree-lined road. (Courtesy of Peter Sarra.)

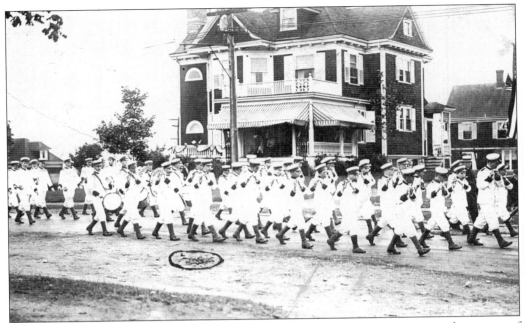

The St. John's Fife and Drum Corps is shown marching by the Capen house at the corner of Washington and Maple Street. This Fourth of July postcard showcases the building that many also know as the Rice Building. The house was built sometime between 1878 and 1882. In 1920, the building was sold to Mabel Rice. Dr. Herbert A. Rice maintained his medical practice there. (Courtesy of the Canton Public Library, Daniel Keleher Collection.)

This undated postcard shows the Charles Sumner house on Chapman Street, which was built around 1888. Sumner was a successful real-estate developer and lived here with his wife Elizabeth and daughter, Annie. In fact, the back of this postcard reads "Annie Sumner House." (Courtesy of Peter Sarra.)

The Bicentennial
of the Constitution of
the United States
of America

PHILADELPHIA, PA
SEP
17
1987
19104

USA 22

FIRST DAY

U.S. Constitution

We the People

1787-1987 22 USA

Roger Sherman

1787 • THE BICENTENNIAL OF THE CONSTITUTION • 198

Roger Sherman • Connecticut

While not strictly a postcard, this "official first day" cover of the commission on the bicentennial of the United States Constitution is as important to Canton as it is to Connecticut. Roger Sherman was born in 1721 and moved to Stoughton (now Canton) when he was two years old. Sherman grew up here and studied in the grammar school. The Harvard-educated Rev. Samuel Dunbar took notice of Sherman's aptitude and urged his studies. In 1743, after his father's death, Sherman moved by foot with his mother and siblings to New Milford, Connecticut, where he opened the town's first store. Once engaged in politics, Sherman became the only member of the Continental Congress who signed the Declaration of 1774, the Declaration of Independence, the Articles of Confederation, and the Constitution. Thomas Jefferson once said of him, "That is Mr. Sherman, of Connecticut, a man who never said a foolish thing in his life."

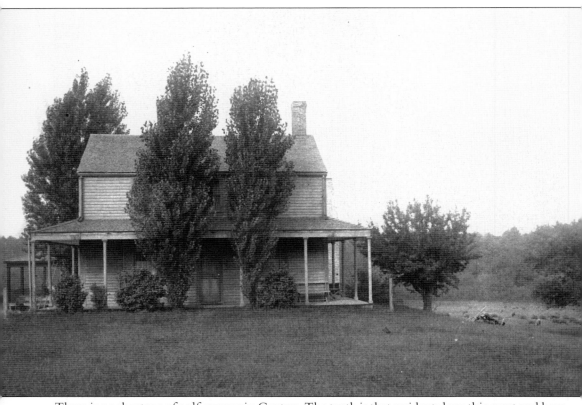

There is no shortage of golf courses in Canton. The truth is that residents love this sport and have a long history on par with just about any other place in Massachusetts. The Hoosic-Whisick Golf Club began in 1892 at Hoosic Lake but was compelled to move when the Metropolitan Park System took the land for the Blue Hill Reservation. In 1919, *American Golfer Magazine* wrote, "Probably outside of the Boston District there are few golfers who ever heard of this club, but it is one of the oldest in the country. Those who once hear of Hoosic-Whisick are not apt to forget it quickly." There are several postcards featuring this club, but this is a photograph taken in May 1907 of the Old Shawley house, which became the site of Hoosic-Whisick clubhouse. (Courtesy of the Canton Historical Society.)

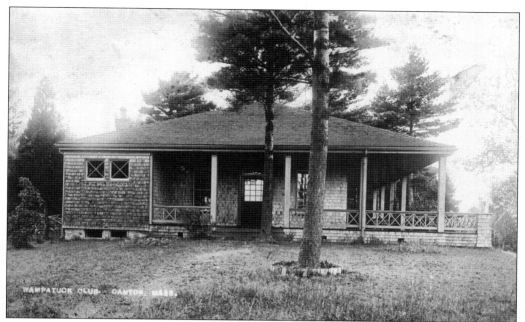

Another venerable old golf club is the Wampatuck Country Club. Incorporated in 1904 with 70 acres of land on the southerly shore of Reservoir Pond, this is a club that many local residents are suitably proud of. The site is splendid and situated on a lovely knoll giving early members a view of the range of the Blue Hill Reservation. In the mid–1920s, the club featured nine holes, tennis courts, and a trap-shooting range. The view above is a postcard from 1911 of the original clubhouse with a wide veranda. Below is an early interior photograph of the clubhouse. (Above, courtesy of Peter Sarra; below, courtesy of the Canton Historical Society.)

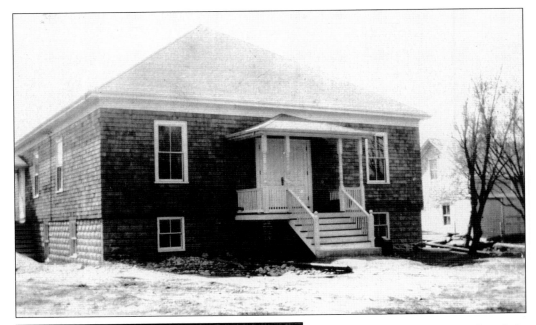

The Ponkapoag Grange was founded in 1903 and is a reminder that this town had a deep connection with farming and livestock. The Patrons of Husbandry Grange No. 231 was located on the hill near the intersection of Route 138 and Randolph Street. The building was dedicated in 1932. In 1953, the Grange had a mortgage-burning ceremony presided over by past master Burr C. Copley. Chief James Fitzpatrick's father was a soloist on this program. At left is the past master pin worn by Henry J. Hope. (Above, courtesy of the Canton Public Library, Daniel Keleher Collection.)

This is a charming rural scene on a small farm in Canton. Ethilida Cushman spends time in the pasture with her "Bossie" cows. This undated private postcard was shared among family members and was used to send Easter greetings. (Courtesy of Charles S. Crespi.)

This is a seldom-seen view of Canton from the "Overlook" on Walpole Street high above the town. Taken in 1911, this provides another glimpse at rural Canton punctuated by smokestacks of industry. In the distance is the Blue Hill, and in the middle of the photograph is Neponset and Chapman Streets, the scenes of so many of the postcards shared in this book. The author's great-grandfather owned the house and barn in the upper right. The playing field in the center of the photograph has yet to be identified. (Courtesy of the Canton Historical Society.)

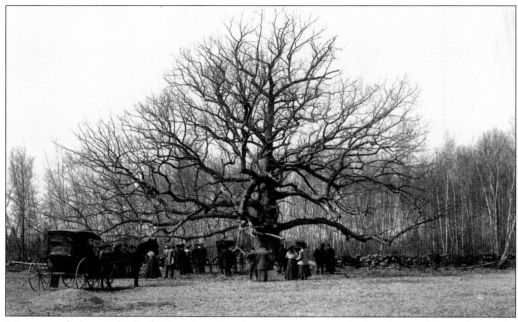

Many people have asked whether there can be so many postcards that feature Canton's people, places, and history. The answer is a surprising yes. Since the late 1800s, organized groups of citizens have showed an active interest in spreading the news and views of the village. The photograph above shows the Fast Day walk described on page 70. The group is organizing themselves around the "Big White Oak" at the Farms. The people are gone and so is the tree. What remains is the interest of people who live here today. Below is a postcard mailed to remind members of the historical society to attend the Fast Day walk for 1917. (Above, courtesy of the Canton Historical Society; below, courtesy of the Canton Public Library.)

THE CANTON HISTORICAL SOCIETY
Incorporated 1893.

THE PATRIOTS' DAY WALK FOR 1917.

Members and guests will meet at the Springdale Railroad Station on arrival of 9 a. m. train from Canton. Will visit the site of the old "Pound," 17th mile stone, Indian burial ground near Burr Lane, site of Simon George dwelling, the old "hornbeam" Muddy Pond, and return via Burr Lane and Quantum Path, visiting the site of various dwellings dating about 1710-25, and later the "Capt. Patrick" house.

Dinner probably near Wampatuck Club grounds. Bring plate, cup, knife, fork and spoon. Please fill out attached postal and forward early.

WALLACE S. SHAW, Clerk.

April 9, 1917.

This book and all preceding histories of Canton would never have been possible without the work of Daniel T. V. Huntoon. The most critical research tool to the people, industries, and places featured throughout this collection of postcards and photographs came from the 1893 *History of the Town of Canton*. Huntoon died at the age of 44, yet he left a thoroughly researched book that is still relevant today. A friend wrote after his death, "the writer of history will pleasantly remember Huntoon, the historian, who infused a new zest in local history, and who was painstaking in gathering material for the future history of the establishment of the great empire of popular government in America, for the cradle of the infant republic was rocked in the ancient town of Stoughton, and under the shadow of the 'Great Blue Hill.' How well Mr. Huntoon knew this, the public will one day know." (Courtesy of the Canton Public Library.)

BIBLIOGRAPHY

Bicentennial Historical Committee. *Canton Comes of Age, 1797–1997, A History of the Town of Canton, Special Edition.* Canton, MA: Friends of the Little Red House, 2004.

Cummings, O. Richard. *The Blue Hill Street Railway.* Bulletin No. 25. Electric Railway Historical Society, 1957.

Galvin, Edward D. *A History of Canton Junction.* Brunswick, ME: Sculpin Publications, 1987.

Huntoon, Daniel T. V. *History of the Town of Canton.* Cambridge, MA: John Wilson and Son University Press, 1893.

Johnson, Patricia. *Historic Homes of Canton, Volume I, Canton Corner.* Canton, MA: Friends of the Little Red House, 2004.

———. *Historic Homes of Canton, Volume II, North Canton Corner.* Canton, MA: Friends of the Little Red House, 2005.

Kantrowitz, Marc R. *Canton.* Charleston, SC: Arcadia Publishing, 2000.

ABOUT THE CANTON HISTORICAL SOCIETY

An early Canton Historical Society member is shown here camera at the ready to help capture a bit of Canton's history. For close to 140 years, the Canton Historical Society has been collecting and preserving Canton's history. Your help is needed to maintain the strength and mission of this institution. Your tax-deductible contributions help ensure that future generations have access to the documents, artifacts, and material crucial to understanding local history. Annual membership dues support the annual operating expenses of the Canton Historical Society that includes utilities, insurance, archival supplies, and ongoing projects. Memberships are a great gift with wonderful benefits. Please become a member and help keep our history alive. For more information, please send a note or stop by the society building at 1400 Washington Street, Canton, Massachusetts, 02021. Please become a member today. Thank you.

www.arcadiapublishing.com

Discover books about the town where you grew up, the cities where your friends and families live, the town where your parents met, or even that retirement spot you've been dreaming about. Our Web site provides history lovers with exclusive deals, advanced notification about new titles, e-mail alerts of author events, and much more.

Arcadia Publishing, the leading local history publisher in the United States, is committed to making history accessible and meaningful through publishing books that celebrate and preserve the heritage of America's people and places. Consistent with our mission to preserve history on a local level, this book was printed in South Carolina on American-made paper and manufactured entirely in the United States.

This book carries the accredited Forest Stewardship Council (FSC) label and is printed on 100 percent FSC-certified paper. Products carrying the FSC label are independently certified to assure consumers that they come from forests that are managed to meet the social, economic, and ecological needs of present and future generations.

FSC
Mixed Sources
Product group from well-managed forests and other controlled sources

Cert no. SW-COC-001530
www.fsc.org
© 1996 Forest Stewardship Council

Find Your Place in History.